A MUSEUM
MISCELLANY

A
MUSEUM
MISCELLANY

Claire Cock-Starkey

Bodleian Library
UNIVERSITY OF OXFORD

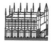

First published in 2019 by the Bodleian Library
Broad Street, Oxford OX1 3BG
www.bodleianshop.co.uk

ISBN 978 1 85124 511 6

ILLUSTRATIONS Bodleian Library, University of Oxford,
pp. 3, 28, 30, 42, 81, 141, 148; Library of Congress, p. 76;
Shutterstock, pp. 14, 16, 21, 67, 77, 82, 84, 101, 107, 128, 132;
Wellcome Collection, pp. 23, 38, 57, 67, 75, 78, 130, 131, 138, 143;
Wikimedia Commons, pp. ii–iii, 41, 71, 89, 103

Cover design by Dot Little at the Bodleian Library
Designed and typeset in 11 on 12 Perpetua by illuminati, Grosmont
Printed and bound in China by C&C Offset Printing Co. Ltd
on 100 gsm Chinese Bai Jin paper

British Library Catalogue in Publishing Data
A CIP record of this publication is available from the British Library

INTRODUCTION

The word *museum* derives from the Greek *mouseion*, which has its root in *mousa*, or Muse. Seats or shrines to the nine mythical goddesses, the Muses, each of whom personified inspiration for a different branch of the arts and sciences, were therefore places of contemplation and became known as *mouseia*. The Latin version of the word, *museum*, initially referred to buildings where philosophical discussion took place. This meaning extended to include intellectual gathering spaces and libraries; for example, when Ptolemy I Soter founded the early university and library at Alexandria in the third century BCE, it became known as the Museum of Alexandria.

The word slowly migrated across Europe but was still mostly used to describe libraries or scholarly locations. It was not until the seventeenth century that *museum* came to be associated with a planned collection of objects – in 1656 the catalogue to John Tradescant's famous cabinet of curiosities was published as *Musaeum*

Tradescantianum. This collection was obtained by Elias Ashmole, who went on to gift it to the University of Oxford as part of the bequest that formed the Ashmolean Museum. The Ashmolean (*opposite*) opened in 1683, becoming Britain's first public museum and cementing both the word and the concept in the English language. Across Europe, as more institutions were created to display art and objects, the word *museum* became more widely used to describe a building to house such a collection.

The notion of a museum as a place of public education developed during the Industrial Revolution, when museums were promoted as an essential part of informal education for the public good. Today the word *museum* is used to describe a huge variety of spaces – large, small, fusty, cutting-edge, public, private, baffling, enlightening – but all serving the same purpose at their heart: public outreach, research and education.

The perception of what constitutes public education has changed over the years and our museums now reflect this. The different ways public education is approached can be explored within these pages. Take, for example, the Gallery of False Principles (*see p. 25*), which was part of the Museum of Manufactures (a precursor to the Victoria and Albert) and sought to define the principles of good taste by exhibiting all that was wrong with design – this type of didactic display was very much of its time and reflected the paternalistic zeal of the Victorians. Today's museums often prefer to leave the interpretation open to visitors. This has

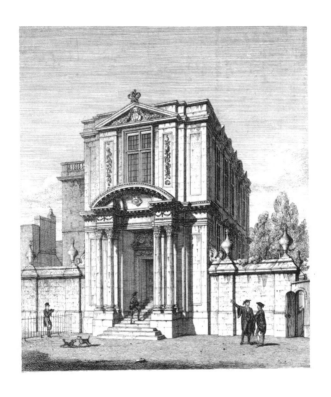

allowed our idea of what constitutes a museum to develop and expand. For instance, the Museum of Broken Relationships (*see p. 86*) exhibits items relating to the end of a love affair, donated to the museum by members of the public, allowing the lives and thoughts of ordinary people and their lived experience to form a reflective, and at times provocative, exhibition.

A Museum Miscellany has collected together a cornucopia of museum-related facts, statistics and lists, covering everything from museum ghosts, minerals that can only be found in museum drawers, dangerous museum objects, the most popular exhibitions, cabinets of curiosity, to the Museum of London's fatberg. By taking a tour through all the nooks and crannies of the museum world *A Museum Miscellany* celebrates these vital and life-enhancing institutions in all their many and varied forms.

The objects of wonder held within our wonderful institutions can provide an antidote to our fast-paced modern life. Museums provide us with spaces to be inspired and revived by the beauty of art and the depth of our cultural history. One of the greatest pleasures of a museum or gallery is to allow oneself the liberty to interpret the objects or art freely, to discover what they mean to you. As nun and art historian Sister Wendy Beckett put it so beautifully: 'A country that has few museums is both materially poor and spiritually poor... Museums, like theatres and libraries, are a means to freedom.'

My hope is that by reading this book you will be encouraged to seek out an unusual museum, explore a digital collection or visit an unfamiliar art gallery. Be inspired, be curious, be awestruck.

THE TOP TWENTY MUSEUMS IN THE WORLD

For the past several years the Louvre in Paris has retained its position as the most visited museum in the world, with a peak of 9.3 million visitors in 2015. It was knocked off its lofty perch and into third place in 2016, but the 2017 figures revealed it had regained the top spot. Below are the top twenty museums in the world by visitor numbers for that year:

INSTITUTION	VISITORS (m)
1. Louvre, Paris	8.1
2. National Museum of China, Beijing	8.0
3. National Air and Space Museum, Washington DC	7.0
3. Metropolitan Museum of Art, New York	7.0
5. Vatican Museums, Vatican City	6.4
6. Shanghai Science and Technology Museum	6.4
7. National Museum of Natural History, Washington DC	6.0
8. British Museum, London	5.9
9. Tate Modern, London	5.6
10. National Gallery of Art, Washington DC	5.2
11. National Gallery, London	5.2
12. American Museum of Natural History, New York	5.0
13. National Palace Museum, Taipei	4.4
14. Natural History Museum, London	4.4

15. State Hermitage, St Petersburg	4.2
16. China Science Technology Museum, Beijing	3.9
17. Reina Sofía Museum, Madrid	3.8
18 National Museum of American History, Washington DC	3.8
19. Victoria and Albert, London	3.7
20. Centre Pompidou, Paris	3.3

The combined attendance for all the museums in the top twenty in 2017 was an astonishing 108 million. The USA has the most museums in the top twenty with six, followed by the UK with five and China with three.*

* Source: Themed Entertainment Association and AECOM, *Theme Index and Museum Index 2017*, Los Angeles CA.

MUSEUM GHOSTS

Museums and galleries can be spooky places after dark, so it is perhaps unsurprising that many legends of hauntings have grown up around some of our most famous museums:

SMITHSONIAN INSTITUTION James Smithson (1765–1829), founder of the Smithsonian, is said to stalk the halls of the hallowed museum he helped to found, which is interesting, since in life the British scientist never set foot on American soil. Smithson died while in Italy. In 1904 the cemetery in San Benigno was to be demolished, so his sarcophagus was removed to the museum in Washington DC. Rumours abounded that Smithson's ghost was haunting the 'Castle', the administrative heart of the museum, and so in 1973 his body was briefly exhumed. Researchers found his skeleton complete, which officially put the ghostly rumours to rest.

THE V & A'S HAUNTED CHAIR A beautiful green *bergère* armchair which once belonged to the famous English actor David Garrick (1717–1779) is supposedly haunted by his wife, Eva Marie Veigel. It is said that a number of times a day the cushion of the chair mysteriously deflates as the ghost of Eva takes a seat.

HAMPTON COURT PALACE The former home of Henry VIII contains many wonderful tapestries and objects relating to his reign, but he also left behind a

few ghosts. Visitors have reported hearing the screams of Catherine Howard begging the king for mercy, as she stalks through the aptly named Haunted Gallery. Jane Seymour, who died in childbirth at the Palace, has also been spotted, lighted taper in hand, wandering through Clock Court up the Silverstick Stairs. It is not only royalty who haunt the palace. Sybil Penn, the nurse of Prince Edward, died in 1562 and was buried at Hampton Church, which was later demolished, disturbing her remains. Since then Penn's ghost, known as the Grey Lady, haunts the rooms where she used to live and work. The sound of a spinning wheel was often heard behind a wall in the palace, and later a concealed room was discovered, complete with spinning wheel.

CLEVELAND MUSEUM OF ART Stories have emerged over the years of haunted paintings in the west wing of the museum. A boy has been spotted a number of times running through the gallery dressed in an identical fashion to a boy in one of the paintings displayed there. Other visitors claim to have seen a man in grey standing in front of the portrait of Jean-Gabriel du Theil and slowly fading into it.

THE LOUVRE Rumours abound that the original thirteenth-century dungeon in the Louvre harbours evil spirits. Visitors have reported strange orbs and spooky shadows appearing in photographs they have taken down there.

Reina Sofía Museum, Madrid This museum was built on the site of an enormous old hospital complex which stood from 1603 to 1974. When the refurbishment was being carried out in the 1980s skulls, shackles and chains and the skeleton of a child were all uncovered. It is perhaps unsurprising, then, that today visitors report hearing muffled screams and disembodied voices and catch glimpses of ghostly forms passing through the Museum.

SIR HANS SLOANE

Over the course of his life physician Sir Hans Sloane (1660–1753) compiled one of the greatest collections of natural specimens, books, objects and curios of his time. Sloane was born in Killyleagh, Ireland, and went on to study medicine in England and France. In 1687, as a private physician, Sloane accompanied the new governor of Jamaica, the Duke of Albemarle, to the island and his passion for collecting natural history specimens was ignited. Sloane came back with over 800 specimens, which signalled the start of his serious collecting. In 1689 he set up what went on to be a highly successful medical practice at 3 Bloomsbury Place in London and began filling the rooms with the fruits of his finds. As a consequence he quickly ran out of space and ended up buying 4 Bloomsbury Place next door as well. Sloane continued practising

medicine, serving as a physician to Queen Anne and Kings George I and II, becoming president of the College of Physicians in 1719 and succeeding Sir Isaac Newton as the president of the Royal Society in 1727.

Sloane's collection progressed and greatly expanded when he acquired a number of other collections, such as those of Mark Catesby (*c.* 1683–1749), Leonard Plukenet (1642–1706) and William Courten (1642–1702). By 1742 he needed yet more space and moved to a manor house in Chelsea. Some of Sloane's most enduring contributions were naming the avocado (in his 1696 catalogue of Jamaican plants) and bringing the recipe for hot chocolate from Jamaica back to Britain. By the end of his life Sloane's marvellous collection had reached some 71,000 objects, including a herbarium, medals and coins, books, manuscripts and antiquities. Sloane bequeathed the items to the nation in return for £20,000 for his heirs, and in June 1753 an Act of Parliament was passed establishing the British Museum with his collections as its foundation. Later in 1881 the Natural History Museum was created to further build on his plant and animal specimens. Sloane's legacy therefore continues to delight and inspire millions of museum visitors every year, a fitting memorial to this most passionate of collectors.

MUSEUM TREASURES:
REMBRANDT'S *THE NIGHT WATCH*

Rembrandt Harmenszoon van Rijn (1606–1669) was commissioned in *c.*1639 to paint the militia led by Captain Frans Banninck Cocq, and came up with a group scene that is recognized for its groundbreaking composition and use of light. The painting, finished in 1642, was given the popular title *The Night Watch** in the eighteenth century, after time and dirt had darkened the varnish, producing the assumption that it depicted a night scene (it does not). *The Night Watch* is an enormous painting, measuring 12 feet by 14 feet, making many of the painted figures almost life-size. When in 1715 it was moved to Amsterdam's town hall, the canvas was cut down to fit, meaning that two figures plus the top of the arch have been lost. Fortunately a small copy of the original survives which reveals the full composition.

When the Rijksmuseum in Amsterdam was built in 1885 *The Night Watch* had a room specially built to hold the museum's greatest treasure. Such is its value that a trapdoor was installed beneath it in 1934, through which it can be whisked away in the event of disaster. The iconic masterpiece has inexplicably been attacked on three separate occasions (*see p. 34*), but fortunately has been fully restored. As a result of the

* There are a number of official titles, all along similar lines to: *Officers and Other Civic Guardsmen of District II of Amsterdam, under the command of Captain Frans Banninck Cocq and Lieutenant Willem van Ruytenburch.*

attacks the famous painting now has a guard assigned to it at all times.

From July 2019 the painting will undergo a new restoration project. Conservators will work on the painting inside a glass box so that visitors to the Rijksmuseum can watch the work unfold and ask questions. Additionally the conservation efforts will be livestreamed on the Internet, giving the public unprecedented access to the conservation process.

MUSEUM OF THE YEAR

Created in 2001 the Museum of the Year award is the largest prize in the UK art world, offering £100,000 to a UK institution which demonstrates 'imagination, innovation and excellence'. The prize is currently sponsored by the Art Fund but prior to 2008 it was known as the Gulbenkian Prize as it was sponsored by the Calouste Gulbenkian Foundation. Below are all the winners of the Museum of the Year prize since it was first awarded in 2003:

2003 National Centre for Citizenship,
 Galleries of Justice, Nottingham
2004 Scottish National Gallery of Modern Art,
 Edinburgh
2005 Big Pit National Coal Museum, Blaenavon,
 Torfaen

2006	SS *Great Britain*, Bristol
2007	Pallant House Gallery, Chichester
2008	The Lightbox, Woking
2009	Wedgwood Museum, Stoke-on-Trent
2010	Ulster Museum, Belfast
2011	*A History of the World in 100 Objects*, British Museum, London
2012	Royal Albert Memorial Museum, Exeter
2013	William Morris Gallery, Walthamstow
2014	Yorkshire Sculpture Park, Wakefield
2015	Whitworth Art Gallery, Manchester
2016	Victoria and Albert Museum, London
2017	The Hepworth Wakefield
2018	Tate St Ives

THE SMALLEST MUSEUM IN THE WORLD

A number of attractions lay claim to the title of the smallest museum in the world, although to date no official title has been recognized by record-giving bodies. The boldly named WORLD'S SMALLEST MUSEUM's eclectic collection of local memorabilia resides in a roadside shed in Superior, Arizona, which measures a modest 134 square feet. The MMUSEUMM in New York is housed in a disused freight elevator and aims to display modern cultural objects which are otherwise overlooked. The space is a tiny 36 square feet and can fit just three or four people in at a time.

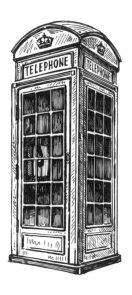

However, in 2016 the WARLEY MUSEUM in West Yorkshire stepped into the fray, with its local objects displayed in an old red British Telecom phone box. As only one person can safely enter at a time, they are confident that their mini-museum can safely claim the title of smallest museum in the world.

PRADO MUSEUM

Today the Prado in Madrid, Spain, holds the world's most complete collections of Velásquez, Goya and El Greco, and boasts over 7,600 paintings in its world-class collection. The Museum has its root in the royal collection of the Habsburg and Bourbon monarchs of Spain, hence its great wealth of Spanish art. King Carlos III (1716–1788) commissioned a natural-history cabinet in 1785 and employed architect Juan de Villa-nueva. The building was finally opened to the public in 1819 but repurposed by King Ferdinand and Queen Isabella as the Royal Museum of Paintings and Sculptures. It was renamed Museo Nacional del Prado in 1868 – *prado* translates as 'meadow' or 'lawn' and was so-called because the site used to overlook market gardens. The museum's first catalogue was produced in 1819 and listed 311 paintings, mostly derived from the royal collection. The treasures of the collection include:

The Garden of Earthly Delights by Hieronymus Bosch
Las Meninas by Velázquez
The Three Graces by Rubens
The Pearl by Raphael
The Washing of the Feet by Tintoretto
The Third of May 1808 by Goya
Self-Portrait by Dürer
The Nobleman with his Hand on his Chest by El Greco

THE TEN MOST EXPENSIVE
PAINTINGS EVER SOLD

Many of the world's most valuable pieces of art will never be sold as they proudly reside in museum collections. However, a number of wonderful paintings remain in private hands and occasionally come up for auction, often causing a sensation. In November 2018 the auction record for a painting by a living artist was broken when David Hockney's *Portrait of an Artist (Pool with Two Figures)* was sold in New York for $90 million (£70 million). Yet, this was not enough to break into the top ten most expensive paintings ever sold. Compiling an accurate list of the world's most expensive paintings is notoriously difficult as buyers do not always disclose the exact amount they paid for an artwork. The figures below should therefore be taken as estimates. The top ten most expensive paintings ever sold (as of July 2018) are as follows:

1. *Salvator Mundi* by LEONARDO DA VINCI
 This painting of Jesus, thought lost for many years, was commissioned by King Louis XII of France over 500 years ago. The auction of the masterpiece in November 2017 generated huge interest and the painting eventually went for $450.3 million. It is now owned by the UAE Department of Culture and Tourism. Plans to display it at the Louvre Abu Dhabi were recently postponed.

2. *Interchange* by WILLEM DE KOONING
 This abstract landscape by de Kooning was completed in 1955 and immediately sold for $4,000. A number of private sales later and the value of the painting had increased substantially. In 2015 it was sold to American hedge-fund manager Kenneth C. Griffin for $300 million.

3. *The Card Players* by PAUL CÉZANNE
 Five versions of this painting exist, including one on show at the Musée d'Orsay in Paris. In 2011 another was sold at a private sale to the royal family of Qatar for an estimated $250 million.

4. *Nafea Faa Ipoipo* (*When Will You Marry?*) by PAUL GAUGUIN This beautiful depiction of two Tahitian girls within a bright landscape was painted in 1892. It was sold in 2014 to the royal family of Qatar at a private sale for an estimated $210 million.

5. *Number 17A* by JACKSON POLLOCK
 At the same sale at which he bought *Interchange*, Kenneth C. Griffin also invested around $200 million on Jackson Pollock's 1948 drip painting.

It is interesting to note that both paintings bought by Griffin appeared in the 1949 *Life* magazine article which brought fame to abstract expressionism, de Kooning and Pollock.

6. *No. 6 (Violet, Green and Red)* by MARK ROTHKO A Russian billionaire purchased Rothko's 1951 abstract expressionist painting in 2014 for around $186 million.

7. Pendant portraits of Marten Soolmans and Oopjen Coppit by REMBRANDT This pair of works by the Dutch master Rembrandt, painted in 1634 and standing at 2 metres high, were jointly bought by the Louvre and the Rijksmuseum in 2015 for around $180 million.

8. *Les femmes d'Alger (Version 'O')* by PABLO PICASSO Part of a series of fifteen paintings and drawings by the Spanish artist. They were originally bought in their entirety in 1956 by art collectors Victor and Sally Ganz for $212,500. The Ganzs have since sold off a number of the individual paintings, including *Version 'O'*, in 2015 for $179.4 million.

9. *Nu Couché* by AMEDEO MODIGLIANI This reclining nude painted in 1917 was sold to a Chinese billionaire in 2015 for $170.4 million.

10. *Masterpiece* by ROY LICHTENSTEIN This 1962 pop art painting fetched $165 million at a private sale in 2017.

A SNAPSHOT OF BRITAIN'S MUSEUMS

The Museum Association's *Museums in the UK Annual Survey 2018* gives a snapshot of the museum sector in Britain:

TYPES OF MUSEUM

Independent	43%
Local authority	24%
National	10%
Independent former local authority	6%
Military	4%
University	4%
National Trust	1%
National Trust for Scotland	0.2%
Historic Scotland	0.2%
Other	7%

GEOGRAPHICAL SPREAD

South of England (including London)	30%
Central England	23%
North of England	26%
Scotland	9%
Wales	6%
Northern Ireland	3%
Isle of Man	3%

In most museums, visitor numbers increased in 2016/17, with 46 per cent reporting that visitor numbers were up; however, sadly 11 per cent of museums had been forced to reduce their opening hours due to funding

cuts. While local authority funding has drastically reduced in recent years, many museums have seen an increase in earned funding (such as from museum shops and cafés), grants and donations. Despite increasing financial pressures, many museums have prioritized outreach and educational work, with 42 per cent reporting increased school visits.

TREASURE

Lucky farmers and metal detectorists have, over the years, unearthed some amazing artefacts which ought to be saved for the nation. Since the early medieval period England has used common law to claim for the Crown found goods of great value which may have been buried to be later reclaimed. This original law, however, did not cover some important finds, such as the famous Anglo-Saxon ship burial at Sutton Hoo* – ineligible as treasure because it had been buried without future plans to retrieve it. The holes in the legislation were thus closed with the Treasure Act 1996,† which rules that any finds of treasure must be reported to the local coroner within fourteen days of

* Fortunately the amazing Anglo-Saxon artefacts of Sutton Hoo were presented to the British Museum in a 1939 bequest by landowner Edith Pretty after they were uncovered on her land by archaeologist Basil Brown.

† This Act only applies in England and Wales. The rules for Scotland and the Isle of Man are quite different; for example, in Scotland items do not need to be precious metal to qualify as treasure.

the discovery (or within fourteen days since the finder realized their find was treasure). The Treasure Act defines treasure as:

- Any metallic object, other than a coin, provided that at least 10 per cent by weight of metal is precious metal (that is, gold or silver) and that it is at least 300 years old when found. If the object is of prehistoric date it will be treasure provided any part of it is precious metal.
- Any group of two or more metallic objects of any composition of prehistoric date that come from the same find.
- Two or more coins from the same find provided they are at least 300 years old when found and contain 10 per cent gold or silver (if the coins contain less than 10 per cent of gold or silver there must be at least ten of them). Only the following groups of coins will normally be regarded

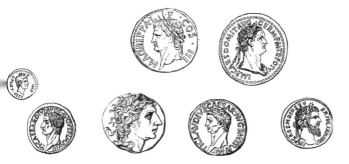

as coming from the same find: hoards that have been deliberately hidden; smaller groups of coins, such as the contents of purses, that may have been dropped or lost; votive or ritual deposits.

- Any object, whatever it is made of, that is found in the same place as, or had previously been together with, another object that is treasure.

Treasure can be reported to the local Finds Liaison Officer, who can help to ascertain if the find is treasure or not. If it is, it will be reported to the coroner and referred to the Treasure Section at the British Museum or the National Museum Wales, depending on where the treasure was found. A report is then compiled on the item to describe it, and this is circulated to museums which may have an interest in acquiring the treasure. If museums express an interest the coroner will hold an inquest to establish if the find is treasure and who the rightful finder and landowner are. If the object is treasure it means the Crown is recognized as the owner. However, the finder and landowner can be issued with a reward for the find, the value of which is decided by the Treasure Section. Once this process has been completed the Crown disclaims its right to the item and it can pass into the collection of the interested museum, preserving it for the nation.

SOME TREASURE FINDS OF NOTE

THE LEEKFRITH IRON AGE TORCS Just before Christmas 2016 metal detectorist friends Mark Hambleton and Joe Kania uncovered what are thought to be the oldest Iron Age gold work to be found in Britain. The four gold torcs, thought to be *c.* 2,500 years old, were unearthed in a field in Leekfrith, Staffordshire, and an inquest concluded they were treasure. At the time of writing the reward amount and the museum collection to secure the torcs have yet to be decided.

THE WATLINGTON HOARD James Mather discovered this Viking hoard of silver bracelets and coins in a field in Watlington near Oxford in 2015. The find includes the very rare 'two-emperors' coin, which has Alfred the Great and Ceolwulf II of Mercia side by side, suggesting an alliance existed between the two kingdoms.

The hoard was thought to have been buried some time after 878 when King Alfred defeated the Viking army at the Battle of Edington. The hoard was sold to the Ashmolean Museum in Oxford for £1.35 million.

The Staffordshire Hoard This find represents the largest haul of Anglo-Saxon gold and silver work ever found, with over 3,500 items. The hoard was probably buried in the seventh century. It was uncovered in 2009 by metal detectorist Terry Herbert in a field near Lichfield in Staffordshire. The hoard was valued at £3.285 million and sold to Birmingham Museum and Gallery and Potteries Museum and Art Gallery with the help of public donations and grants from the National Heritage Memorial Fund. The reward was split by Herbert and the landowner.

The Lenborough Anglo-Saxon Coin Hoard This hoard of 5,251 silver Anglo-Saxon coins was discovered by Paul Coleman buried wrapped in a sheet of lead near the village of Lenborough in Buckinghamshire in 2014. The coins came from forty different mints around the country and included depictions of both King Canute and Ethelred the Unready. The hoard, valued at £1.35 million, was purchased by Buckinghamshire County Museum.

The Frome Hoard The second-largest collection of Roman coins found in Britain was unearthed by amateur metal detectorist Dave Crisp in 2010 in a field near Frome, Somerset. The 52,503 bronze and

silver coins, dating from the third century CE, were left hidden in a large pot. A number of the coins were minted in the reign of Carausius, who was the first Roman emperor to mint coins in Britain, 286–293. The stash was bought for £320,250 by the Museum of Somerset.

THE GALLERY OF FALSE PRINCIPLES

Following the success of the Great Exhibition of 1851, at which British manufacturing was promoted and celebrated, it was proposed that many of the exhibits be transferred to create a museum. Civil servant Henry Cole (1808–1882) was to be the first director of the Museum of Manufactures, which opened its doors in Marlborough House, London, in 1852, in what would be a precursor to the South Kensington (now Victoria and Albert) Museum. Cole was keen that the Museum should provide the public with an education in the principles of good design, and as a result he not only furnished rooms with outstanding examples of furniture, ceramics, metal works and glass; he also proposed the creation of a special room to display all that was wrong in design. The room was called the Gallery of False Principles (although the press soon dubbed it the 'Chamber of Horrors') and contained a series of objects thought to exemplify bad taste, including:

- A pair of scissors shaped like a stork.
- A pink vase in the shape of a snake.
- A blue earthenware jug in the shape of a tree trunk with out-of-proportion vine leaves and grapes.
- A brass gas lamp in which the flames projected from the petals of a convolvulus.
- Pocket handkerchiefs with direct imitations of landscapes, animals and vessels.
- A carpet made to look like Gothic oak wood panelling.

The accompanying catalogue contained critiques of the offending objects and Cole's ire was particularly raised by excessive use of floral ornamentation (especially if it were oversized); anything depicted on a carpet that one would not usually walk upon, such as buildings, clouds or animals; pictures on crockery that would get covered by food; and wallpaper that repeats the same picture over and over again. The *Morning Chronicle* in September 1852 reported that the accompanying catalogue was very informative, with 'a great mass of admirable criticism' which pointed out the fault of each item therein, including 'direct imitation of nature; incongruity of design; inaptness of ornament; disregard of utility, or vulgar taste generally'. The Gallery proved very popular with the public. However, it soon closed after many of the offended manufacturers of the objects featured within requested the return of their goods.

THE HERMITAGE

The State Hermitage Museum in St Petersburg, Russia, was established in 1764 by Empress Catherine the Great. The collection sprawls across a complex of six buildings, including the Winter Palace, which was built 1754–62 as the main residence of the tsars. The basis of the Museum collection was formed from the 225 paintings by old masters acquired by Johann Gotzkowsky for King Frederick II of Prussia. Frederick, badly in debt after the Seven Years War, refused to pay for the collection. Catherine the Great was only too pleased to purchase the paintings herself, marking the beginnings of the now world-famous museum. Catherine continued to amass works throughout her life and acquire other collections. By her death, there were at least 4,000 paintings in the Hermitage collection, which at that time was private. In 1852 the New Hermitage building was opened to the public, but it was not until after the revolution in 1917 that the entire complex was declared a state museum. Below are some facts about the museum:

Area of the complex (m²)	233,345
Area of exhibition space (m²)	66,842
Items in the inventory:	3,150,428
paintings	17,127
sculptures	12,802
archaeological artefacts	784,395
coins and medals	1,125,623
weapons and armoury	13,982

The Museum complex is also home to a sizeable population of cats, a tradition which began in 1745 when Empress Elizabeth decreed that a large number be sent to the palace to deal with the mice problem. Cats have since been a permanent feature at the complex (except, of course, during the 900-day Siege of Leningrad of 1941–44 when severe food shortages meant the cats could not be sustained; indeed quite probably they themselves sustained the pitiable besieged residents of the city). Today some seventy-five felines reside in the museum buildings, occasionally straying into the galleries themselves.

THE MUSEUM OF ISLAMIC ART

The Museum of Islamic Art opened in Doha, Qatar, in 2008. The building, a charming conflation of traditional Islamic architecture and modernist clean lines, was designed by Chinese-American architect I.M. Pei – the man who designed the Louvre's famous glass pyramid. It sits on island of reclaimed land at the tip of Doha and is reached via a footbridge. The collection encompasses over 800 works of art from textiles to glass, early Islamic texts and sculpture. Objects from three continents and spanning 1,400 years are displayed, showing the depth and breadth of Islamic art.

THE DIORAMAS AT THE AMERICAN MUSEUM OF NATURAL HISTORY

Museums are places where people can go to experience objects, art and scenes which are uncommon in everyday life. Nothing sums up this escapist sentiment more than the famous diorama halls at the American Museum of Natural History. When the first dioramas were created in the early 1900s few ordinary people had the opportunity to travel the world; these evocative 3D scenes brought the habitats to the people, depicting exotic animals in a re-creation of their natural environments. French artist Louis Daguerre, inventor

of the early photograph the daguerreotype, patented the term *diorama* (from the Greek words for *through* and *sight*) when in 1822 he layered up painted translucent screens which could be lit from behind to reveal a sort of three-dimensional theatrical scene. This was later applied to natural-history scenes. The first museum diorama was created by Carl Akeley (1864–1926) in 1889 for a museum in Milwaukee – it depicted muskrats swimming through a river.

The first dioramas at the American Museum of Natural History (AMNH) were created in the late nineteenth century by Frank M. Chapman (1864–1945), the curator of birds. Chapman collected

eighteen different bird species and their nests, displayed with a beautiful painted backdrop, for the Hall of North American Birds. Akeley subsequently helped to develop the AMNH's now famous Hall of African Mammals.* These scenes required a lot of research as authenticity was vital – the team developed advances in taxidermy to make the animals look as lifelike as possible, and Akeley spent time in Africa collecting samples and composing realistic scenes, which was not without its hazards.† The Andros Coral Reef diorama, which shows an above- and below-the-water scene, was created between 1924 and 1935. It took 40 tons of coral. The colourful fish collected were then reproduced in beeswax. Although today these kinds of scene are perceived as antiquated, scientists have realized their value as unique preserved slices of pristine biodiversity – the research skills of the curators meant that the accuracy in the dioramas was such that they have preserved habitats that in some cases are now extinct.

Many American museums have dismantled their now unfashionable dioramas, or added high-tech interactive elements to upgrade them into the twenty-first

* In 1909, Theodore Roosevelt personally shot and collected one of the eight huge stuffed elephants which form a central part of this scene.

† During one of these trips Akeley sustained injuries after an unfortunate encounter with a leopard. Akeley had been hunting for specimens of ostrich and hyena when a leopard charged at him; he responded with gunfire, injuring the leopard, but was soon out of bullets. There followed a long and bloody tussle during which the leopard held Akeley's arm in its mouth while the stricken taxidermist used his brute strength to eventually choke the leopard to death.

century. However, the AMNH still celebrates and maintains its many dioramas, providing the perfect space to experience this dying art of natural-history display.

THE DEFINITION OF A MUSEUM

According to the statutes agreed by the International Council of Museums (ICOM) in 2007,

> A museum is a non-profit, permanent institution in the service of society and its development, open to the public, which acquires, conserves, researches, communicates and exhibits the tangible and intangible heritage of humanity and its environment for the purposes of education, study and enjoyment. (*Article 3, section 1*)

ICOM was established in 1946 by and for museum professionals. Its purpose is to promote professional management of museums and to further the public's understanding of the nature, role and future of museums. ICOM has representatives from 117 countries, representing 20,000 museums worldwide.

MUSEUM BREAKAGES

Everyone has their clumsy moments, but when such a moment involves a priceless artefact or artwork it can be disastrous. Various museums have seen works damaged by accident or design, some of the most memorable of which are given below:

ANDREA DELLA ROBBIA's *Saint Michael the Archangel* In 2008 this terracotta relief by the Renaissance sculptor Andrea della Robbia fell from its place above a doorway in New York's Metropolitan Museum of Art in the middle of the night. Fortunately the relief flipped over as it fell and landed on its back, meaning that although the piece was damaged, it was not irreparable. After painstaking conservation the beautiful relief was restored and securely rehung back in the European Sculpture and Decorative Arts gallery.

TRACEY EMIN's *Self-Portrait: Bath* During a retrospective of Emin's work at the Scottish National Gallery of Modern Art (SNGMA) in 2008 a visitor accidentally caused thousands of pounds' worth of damage to *Self Portrait: Bath*. The work, which includes a tin bath and a neon light wrapped in barbed wire, was damaged when the visitor's skirt got tangled in the wire and, as she pulled away, a piece of the neon light snapped off. Fortunately the piece was fully restored.

QING DYNASTY VASES Loose shoelaces caused a man to stumble down a flight of steps at the Fitzwilliam Museum in Cambridge in 2006 and crash into three

large Chinese Qing dynasty vases. Unfortunately the vases acted like dominos and toppled into each other, causing over £100,000-worth of damage. Despite the vases being smashed into numerous pieces, the dedicated conservators at the Museum managed to painstakingly piece them back together. Today the pieces are back on show, albeit in a protective case.

CARL ANDRE's *Venus Forge* This 1980 artwork, which consists of a 15-metre-long path of copper tiles, was on display at Tate Modern in London when it suffered a rather undignified mishap. In 2007 a sickly child vomited over the work, resulting in a number of the tiles being taken away for specialist cleaning.

REMBRANDT's *The Night Watch* This 1642 painting by the Dutch master, housed at the Rijksmuseum in Amsterdam, has been the subject of a number of in-explicable attacks. In 1911 an unemployed chef decided to try to slash the work with a knife, but fortunately he did not manage to pierce the thick varnish. In 1975 a man repeatedly attacked the painting, slashing zigzags into the canvas in the belief that its destruction was his divine mission. The great work was restored and rehung and placed under close guard. Yet, in 1990 another mentally disturbed man flung acid at the painting. Fortunately it was again saved by its layer of varnish. The carefully restored piece remains on public show.

THE SMITHSONIAN

James Smithson (1765–1829), the illegitimate son of the 1st Duke of Northumberland, was a talented English mineralogist and chemist. He never married, bequeathing his substantial fortune to his nephew with the caveat that, should the nephew die heirless, the money would go to Washington DC to establish a Smithsonian Institution for 'the increase and diffusion of knowledge among men'. Smithson had never set foot in America* and so historians have puzzled over his generosity, but whatever his motivation his philanthropic gesture has been of immense importance to preserving the arts, science and history of the United States. The Smithsonian Institution was signed into being by President James K. Polk on 10 August 1846 after ten years of discussion in Congress over how to interpret Smithson's rather vague bequest. Initially the Institution was intended to be focused on scientific research but it soon began acquiring objects, such as ethnographic and natural-history specimens from the US Exploring Expedition. In 1849 building began on 'the Castle' to hold the collections and it opened in 1855. Over the years the Institution has absorbed a number of other museums and collections, and today the Smithsonian is the world's largest museum and educational complex, boasting nineteen museums, nine research facilities and the National Zoo:

* In 1904 Smithson's body was exhumed and transported to Washington DC to be reburied in the original Smithsonian building (*see p. 7*).

WASHINGTON DC
Anacostia Community Museum
Arts and Industries Building
Freer Gallery of Art
Hirshhorn Museum and Sculpture Garden
National Air and Space Museum
National Museum of African American
History and Culture
National Museum of African Art
National Museum of American History
National Museum of the American Indian
National Museum of Natural History
National Portrait Gallery
National Postal Museum
Renwick Gallery
Arthur M. Sackler Gallery
Smithsonian American Art Museum
Smithsonian Institution Building (the 'Castle')

NEW YORK
Cooper Hewitt, Smithsonian Design Museum
National Museum of the American Indian,
George Gustav Heye Center

CHANTILLY, VIRGINIA
National Air and Space Museum,
Steven F. Udvar-Hazy Center

The museums have a total of some 154 million objects, which are largely made up of the 145 million scientific specimens at the National Museum of Natural History. Over 28 million people visit one of the museums (or zoo) in the Smithsonian group every year.

THE MUSEUM OF 'FAKES'

The Otsuka Museum of Art, in north-eastern Japan, which opened in 1998 to celebrate the seventy-fifth anniversary of the Otsuka Pharmaceutical Group, has collected and displayed over 1,000 copies of famous works of Western art, allowing people to view copies of some of the most famous paintings in the world (many of which are too fragile or valuable to travel) from 190 different museums and twenty-six countries, all in one place. The paintings are all reproduced in full colour by transfer-printing them from photographs onto special ceramic panels which ensure the colours will not fade. The enormous museum has the largest exhibition space of any in Japan at 29,000 square feet. The reproductions in the museum include:

A full-size replica of the Sistine Chapel
The Last Supper by Leonardo da Vinci
Guernica by Pablo Picasso
All of Rembrandt's self-portraits
Water Lilies by Claude Monet
Girl with a Pearl Earring by Johannes Vermeer
The Church at Auver-sur-Oise by Vincent van Gogh
The Birth of Venus by Sandro Botticelli

THE OXFORD DODO

Dodos were first encountered by Europeans on the island of Mauritius in 1598. This large flightless bird was exceptional in its strange squat body and large beak. Unfortunately being unable to fly meant that as pigs, dogs and cats were introduced to the island the birds' habitat and eggs were destroyed, causing the population to crash, and by 1680 they were extinct. A number of specimens of the curious bird were brought to Europe by collectors, including by John Tradescant, whose collection was later bought by Elias Ashmole.

Such was the clamour for specimens that all were broken up into pieces and today no whole skeletons remain. Ashmole's dodo comprises just the mummified skull and foot and yet represents the most complete and scientifically valuable dodo remains in the world. Today the Oxford dodo resides at Oxford University's Museum of Natural History, where it is kept safely in storage. On display instead is a composite model and reconstruction of a dodo compiled from a number of different skeletons. The soft tissue remains of the mummified Oxford dodo have provided scientists with a sample of its DNA, which indicated that its closest living relative is the Nicobar pigeon, native to South East Asia. CT scans of the skull, completed by researchers at the University of Warwick, revealed traces of lead pellets embedded in the bone, suggesting this dodo was shot in the head.

THE CENTRE POMPIDOU

Paris's modern art museum the Centre Pompidou is today an iconic building. The innovative inside-out design, enabling the inner space to be free of columns, was designed by the (at that time) relative unknowns Renzo Piano and Richard Rogers, alongside Arup engineers and Gianfranco Franchini. It was built between 1970 and 1977 and was immediately controversial – the sight of the exposed ductwork and

brightly coloured pipes, usually hidden inside the walls of a building, was a revolutionary design. The arts centre was named after President Georges Pompidou, whose administration had rubber-stamped the project. When he first saw the plans for the building (chosen through an international competition with 681 entries) he quipped: 'This is going to make a noise' – and he was right. Critics were quick to decry the building as a blight on beautiful Paris, its industrial and radically modern aesthetic seemingly at odds with the grand Parisian skyline. The public disagreed and flocked to ride the escalators and enjoy the modern art within. By 1987, just a decade after it had opened, it was tempting in more visitors than Paris's previous icon of modernity, the Eiffel Tower (7 million visitors compared to the Eiffel Tower's 4.1 million in 1987). The museum later underwent a three-year refurbishment, reopening in 2000. Today it houses a public library, a centre for music research, and the largest museum of modern art in Europe, Musée National d'Art Moderne.

SOME CELEBRATED
CABINETS OF CURIOSITY

Cabinets of curiosity, or wonder rooms, were small collections of objects such as natural-history specimens, strange phenomena or exotic artefacts. In the early modern period (c. 1500–1800) a number of wealthy explorers, naturalists and antiquarians curated and displayed their collections of objects to friends and acquaintances in a precursor to the modern museum. Many of these early and celebrated cabinets of curiosity went on to form the basis of major museum collections. Below are a number of cabinets of curiosity of note:

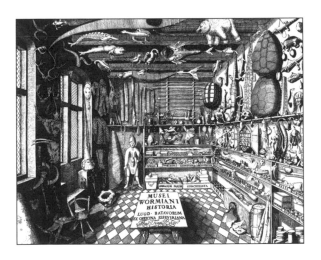

OLE WORM (1588–1654) Worm lived in Copenhagen, where he worked as a physician and taught at the university, all the while travelling, collecting, cataloguing and sketching his collection of natural-history and ethnographic specimens. After his death the catalogue was published as *Musei Wormiani Historia*, containing a marvellous engraved frontispiece which depicts the layout of his 'museum' – an image that has proved of great use to historians studying his collection. Among Worm's many achievements was producing proof that unicorn horns were in fact derived from narwhals and acquiring a live great auk from the Faroe Islands, which he kept as a pet.* After his death, Worm's 'museum' was absorbed into the Danish royal collection; today a number of his objects are on display at the Natural History Museum of Denmark in Copenhagen.

* It was from Worm's pet that the only known sketch of a live great auk was created. This flightless bird became extinct in the mid-nineteenth century.

PETER THE GREAT'S KUNSTKAMMER In 1697 Tsar Peter the Great (1672–1725) visited a remarkable *Kunstkammer* (cabinet of curiosity) in Dresden which had both animal and human specimens on display. Inspired, he decided to create an even bigger version back in St Petersburg. Peter was most keen on debunking myths of monsters and so he appealed to his subjects to bring him singular items for inclusion. As a result, he acquired for the collection a two-headed baby and an eight-legged lamb preserved in vinegar. The museum opened in 1718. Today it is known as the Museum of Anthropology and Ethnography and the collection has grown to over 2 million objects.

FREDERIK RUYSCH'S ANATOMICAL DISPLAYS Frederik Ruysch (1638–1731) was a Dutch anatomist, whose work blurred the boundaries between art and medicine. Ruysch was quite the showman and his candlelit public dissections, accompanied by tasteful music, brought him fame. His extensive cabinet of curiosities in Amsterdam became very popular with visitors, who came to ogle the variety of anatomical specimens preserved in glass jars. Additionally Ruysch created macabre thematic scenes in which small skeletons were posed; for example, a scene depicting the transience of life in which the skeleton of a three-year-old boy held the skeleton of a parrot, alluding to the saying 'time flies'. 'Natural' scenes were also included, in which bushes and grasses were fashioned from human tissue and the rocks from kidney stones.

Ruysch sold the majority of his collection to Peter the Great in *c.* 1717. Although none of the tableaux survive (except as illustrations), some of his specimens can still be seen in St Petersburg today.

TRADESCANT'S ARK The collection formed by gardener and naturalist John Tradescant the elder (*c.* 1570–1638) and his son John Tradescant the younger (1608–1662) was one of the earliest great English cabinets of curiosities. Throughout Tradescant the elder's gardening career he travelled widely, collecting numerous plant and animal specimens, a passion which was then continued by his son. The extraordinary objects – including the cloak of Indigenous North American Chief Powhatan (Chief Wahunsenacawh), the father of Pocahontas – which made up the Musaeum Tradescantianum were displayed at a house in Vauxhall, London, which became known as The Ark, where visitors could look around in exchange for a small fee, in a precursor to the modern natural-history museum. The Tradescants' collection was acquired by Elias Ashmole, who gifted it to the University of Oxford (*see p. 59*).

THE BILBAO EFFECT

The 'Bilbao effect' is today used as a shorthand for the economic and cultural regeneration of a down-at-heel area through the building of an iconic museum or cultural centre. In the 1980s Bilbao, in the Basque region of Spain, had been affected by numerous acts of terrorism by Basque separatists ETA, and the decline of its once buoyant shipbuilding and steel industries. The city needed a shift in focus to kick-start a regeneration, and that came in the shape of a bold new building to house a European arm of the famed Guggenheim Museum. Canadian architect Frank Gehry's design was selected – a titanium and stone confection, resembling a ship launching into the river it overlooks. The project, however, was controversial, in part because a huge amount of public funds was invested, but also due to the bold design of the building in an – at that time – incongruous location. The Guggenheim Bilbao opened in 1997 and was an immediate success. The area was cleaned up, a new metro was built to serve the city, and the opening of the Museum completed this regeneration, attracting millions of visitors and bringing a welcome boost to the local economy. The success of the Guggenheim Bilbao has encouraged other struggling cities to invest in cutting-edge buildings to create cultural centres, proving the enduring value of the arts.

MUSEUM HEISTS

Many major artworks have been stolen from museums over the years. Some have been returned but others remain lost. Below are a number of major museum heists:

THE ISABELLA STEWART GARDNER MUSEUM On 18 March 1990 the single largest property theft took place at the Isabella Stewart Gardner Museum in Boston, USA. Men dressed as police officers arrived at the Museum before it opened for the day and asked to be let in, claiming that they were responding to a disturbance. The unsuspecting guards were lured away from the alarm button, then tied up and hidden in the basement. The thieves then spent 81 minutes stealing artworks by Degas, Vermeer, Manet and Rembrandt worth over $500 million. The crime remains unsolved and a $10 million reward is offered for the return of the thirteen artworks. The Museum has left the empty frames in place as a sign of hope that the paintings will one day be returned.

THE MONA LISA by Leonardo da Vinci was stolen from the Louvre in Paris in August 1911. The resultant press coverage helped make this portrait the most famous painting in the world. Italian handyman Vincenzo Peruggia masterminded the affair after helping to install a protective glass frame for the painting. It is thought Peruggia hid in a cupboard until the museum

closed then stole out and removed the painting from the wall, hiding it in his smock and making off with it. Amazingly museum guards did not notice the disappearance for over twenty-four hours. Peruggia hid the painting in the false bottom of a suitcase, biding his time until the press frenzy cooled. Two years later Peruggia wrote to a Florentine art dealer revealing that he had the painting and wanted it returned to Italy. The dealer notified the authorities and Peruggia was arrested and sentenced to seven months in jail. The *Mona Lisa* was returned to the Louvre unscathed, but with massively increased fame and security.

THE SCREAM In 1994 Edvard Munch's *The Scream* was stolen from the National Gallery in Oslo, with a note left in its place saying 'Thanks for the poor security'. A ransom of $1 million was demanded for its return, but the authorities refused to pay up. Police eventually came up with a sting operation and successfully recovered the painting. Another version of the painting was stolen from the Munch Museum in Oslo in 2004. This time the masked thieves carried out a daring daytime raid, also scooping up Munch's *Madonna*. The paintings were both later recovered, albeit having sustained some damage. Two men were later jailed for the audacious theft.

THE KUNSTHAL MUSEUM THEFT In October 2012 a gang of Romanian thieves broke into the Kunsthal in Rotterdam, making off with paintings by Gauguin,

Monet, Picasso and Matisse worth around $24 million. A number of men were arrested. The mother of the alleged mastermind claimed that she had burned the paintings, probably to destroy the evidence and protect her son.

THE GHENT ALTARPIECE This twelve-panelled 11 foot by 15 foot altarpiece, attributed to Hubert and Jan van Eyck, which is considered one of the treasures of Western art, has over the years been stolen (all or in part) numerous times. The most recent and notable occasion was in 1934 when one of the panels depicting the Just Judges was taken from the altarpiece in St Bavo Cathedral, Ghent. A ransom note for 1 million Belgian francs followed, and part of the panel was returned, but after eleven letters were exchanged with the thief the authorities were no closer to getting the panel back. Months later, stockbroker Arsène Goedertier suffered a fatal heart attack and on his deathbed revealed himself to be the culprit, but he took its hiding place to his grave. Authorities have continued to look for the masterpiece, even carrying out an X-ray search of the entire cathedral, but to this day it remains lost. A replica of the missing part of the panel was made during the Second World War.

THE SALE OF THE LATE KING'S GOODS

Charles I (1600–1649) was a keen collector; over his lifetime he acquired an incredible collection of art, including works by Titian, Dürer, Van Dyck, Rubens and Holbein. On his execution in 1649 the valuable collection became an obvious source of money; as parliament was in dire need of funds after a costly war, it was decided it should be sold off. In those puritanical times it was also seen as correct to sell off the extravagant artworks on which out-of-touch Charles had squandered money when the country had been in economic depression. Initially some buyers were discouraged, worried that they would be seen as profiting from regicide; however, the quality of the works in question soon assuaged any guilt. This important royal collection was thus dispersed across Europe, with some of the choicest paintings ultimately ending up in the galleries of the Prado and the Louvre.

When Charles II came to power after the Restoration he managed to regain parts of the collection, but it was never fully reassembled. In 2018, however, to celebrate the 250th anniversary of the Royal Academy, an exhibition was staged in London reuniting many works from Charles I's original collection, featuring over 100 works of art from tapestries to oil paintings – the first time some items in the collection had been together for over 350 years.

POPULAR EXHIBITIONS

Blockbuster exhibitions can mean an influx of visitors for museums and galleries, boosting their footfall and perhaps introducing new people to their treasures. In 2018 the Shanghai Museum in China hosted five of the top ten exhibitions worldwide by visitor numbers. The top ten most popular exhibitions in 2018, according to *The Art Newspaper,* were:

EXHIBITION	VISITS/DAY
1. *Heavenly Bodies: Fashion and the Catholic Imagination*, Metropolitan Museum of Art, New York	10,919
2. *Michelangelo: Divine Draftsman and Designer*, Metropolitan Museum of Art, New York	7,893
3. *Do Ho Suh: Almost Home*, Smithsonian (SAAM), Washington DC	7,853
4. *Masterpieces from Tate Britain 1700–1980*, Shanghai Museum, Shanghai	7,126
5. *Bronze Vessels*, Shanghai Museum, Shanghai	6,933
6. *Higashiyama Kaii Retrospective 1908–1999*, National Art Center, Tokyo	6,819
7. *Crossroad: The Beliefs and Arts of the Kushan Dynasty*, Shanghai Museum, Shanghai	6,741
8. *The Wanderers: Masterpieces from the State Tretyakov Gallery*, Shanghai Museum, Shanghai	6,666
9. *Jomon: 10,000 Years of Prehistoric Art in Japan*, Tokyo National Museum, Tokyo	6,648

The top-ranked exhibition *Heavenly Bodies* at the Met marked a rising trend in the popularity of exhibitions on fashion. In 2019 the Dior exhibition at London's Victoria and Albert Museum had to be extended by seven weeks after tickets for the entire run sold out within just three weeks of its opening.

AUGUSTUS PITT-RIVERS

Augustus Henry Lane-Fox Pitt-Rivers (1827–1900) came from the landed gentry, but as the younger son of a younger son his prospects were initially relatively poor. Lane-Fox joined the army in 1845 as an ensign. Apart from a month's active service in the Crimea, after which he was declared unfit to serve, he spent most of his army career training others, before formally retiring aged 55 in 1882 as an honorary lieutenant-general. Throughout his life he was fascinated by archaeology and ethnography, and from about 1852 he began collecting a wide variety of artefacts. He was interested not just in rare objects but also in everyday items, and it is this aspect that gave his collection such breadth. Although he collected some items while travelling, the majority of his objects were acquired at auctions or from fellow collectors.

The death of his elder brother in 1852 changed his prospects dramatically and in 1880 he inherited a substantial estate (and the surname Pitt-Rivers) from a distant relative. This financial security and a large country house in Wiltshire meant that he could devote more money and space to his growing collection. Pitt-Rivers wrote that he wanted his collection to provide instruction, and to this end he arranged his ethnographical items in sequence typologically and chronologically – an innovation that so far had only been used in natural-history displays. Heavily influenced by the theories of Herbert Spencer and Charles Darwin, Pitt-Rivers applied their evolutionary theory to this ethnographic collection to show the cultural development of objects.

In 1884 Pitt-Rivers gifted his ethnographic collection of over 27,000 items to the University of Oxford, which established the Pitt Rivers Museum in his honour. The Museum followed Pitt-Rivers' lead and displayed the objects in typological series. This meant that cases might display one class of objects, such as weapons, from all over the world to show how different cultures developed similar objects. Today the collection has grown to over 550,000 objects, but they are still displayed using the method employed by Pitt-Rivers himself.

WRITERS' HOUSE MUSEUMS OF NOTE

A number of fascinating museums have been created in the homes of some of our most celebrated writers, allowing visitors to get a sense of a writers' working environment. Below are some British writers' house museums:

BRONTË PARSONAGE MUSEUM, Haworth, was the family home of Anne, Emily and Charlotte. The location of the house on the edge of the Yorkshire Moors inspired the sisters' writing, and all of their novels were written within its rooms.

CHARLES DICKENS MUSEUM, 48 Doughty Street, London, is where the celebrated author wrote *Oliver Twist*, *Pickwick Papers* and *Nicholas Nickleby*. A classic Victorian family home, the Museum includes Dickens's study, complete with desk and handwritten drafts.

JANE AUSTEN'S HOUSE MUSEUM, Chawton, was where Jane Austen wrote and edited many of her most famous books. The house, acquired as a museum in 1947, holds many personal possessions belonging to Austen, including first editions of her books.

DOVE COTTAGE, Grasmere, was inhabited by William Wordsworth and his sister Dorothy from 1799 to 1808 after he fell in love with the area during a walking tour of the Lake District; they were joined in 1802 by his

wife Mary and her sister; the arrival of three children in four years led to the Wordsworths moving to larger accommodation. The traditional Lakeland cottage was where Wordsworth wrote some of his most celebrated poems. It opened as a museum in 1891, ensuring much of the decor has survived unchanged.

MONK'S HOUSE in Rodmell, Sussex, was the country retreat of Virginia and Leonard Woolf. Numerous members of the Bloomsbury set, including Lytton Strachey, T.S. Eliot and E.M. Forster, were frequent visitors. Virginia's writing lodge, where she spent at least three hours every day, can be seen at the bottom of the garden.

HILL TOP, in the Lake District, was left by Beatrix Potter to the National Trust on her death in 1943; as such it retains a strong sense of her taste and character. The small cottage was Potter's refuge and was where she wrote thirteen of her twenty-three illustrated children's books.

GREENWAY, in Brixham, Devon, was Agatha Christie's holiday home, where she spent many happy times with her friends and family, entertaining them by reading from her latest book. The large home, which retains its 1950s' decoration, reflects Christie's interests, with archaeological objects, numerous books and a beautiful garden.

MUSEUM TREASURES:
GUERNICA BY PABLO PICASSO

The huge mural painting, which measures 3.5 by 7.8 metres, was commissioned by the Republican Spanish government to feature at the Paris Exposition of 1937. Picasso was responding to the Franco-instigated Nazi carpet-bombing of the Basque town of Guernica in the Spanish Civil War, the devastating accounts and photographs of which he saw in the newspapers that year.

Picasso completed numerous studies for the piece, before combining his ideas into a potent whole, symbolizing the futility and barbarity of war. The painting took just three weeks to complete; its muted palette of black, white and greys contribute to its stark effect.

Despite its now legendary status, the painting was largely overlooked at the Paris Exposition. Later, however, it went on a world tour, casting a spotlight on the horrors of the Spanish Civil War and gaining plaudits for its composition. As World War II broke out Picasso asked the Museum of Modern Art (MoMA) in New York to keep the painting safe until the war was over, going on to extend this loan until there was democracy in Spain. This gesture helped to highlight the plight of his home country and served to cement Guernica as a potent anti-war painting and symbol of hope.

Picasso did not live to see his painting's triumphant return to Spain in 1981. Guernica was initially housed

at the Prado in Madrid, before being moved to Centro de Arte Reina Sofía in 1992, where it is displayed behind a thick layer of bulletproof glass, a testimony to the painting's still highly politicized legacy.

THE MINERAL WHICH ONLY EXISTS IN MUSEUM DRAWERS

The rare mineral calclacite was first noted in the 1950s when it was observed growing on artefacts kept in the oak storage drawers at the Museum of Natural Sciences in Brussels. This mineral only occurs due to human actions, meaning it is anthropogenic. Calclacite is a translucent, silky mineral which is created when calcareous specimens of fossil, pottery sherds or rocks interact with the acetic acid in oak storage drawers, making this very rare mineral unique to museums.

THE OLDEST MUSEUMS IN THE WORLD

Throughout history humans have had a natural urge to collect. This is represented by the numerous private collections of objects and art which have often formed the basis of many public museums. Below is a summary of some of the oldest museums in the world:

PRINCESS ENNIGALDI'S MUSEUM, Ur In 1925 famed archaeologist Leonard Woolley unearthed from an ancient Babylonian palace in Ur (modern-day Iraq) what appeared to be an ordered and labelled collection of Mesopotamian objects dating from 2100 to 600 BCE. Further investigation indicated that the artefacts could represent the world's first museum, as curated by Princess Ennigaldi, daughter of Nabonidus – the last king of the Neo-Babylonian Empire. From 530 BCE, Ennigaldi collected items charting the history of Mesopotamia. The museum remained active until 500 BCE, when the city of Ur was abandoned due to a prolonged drought.

CAPITOLINE MUSEUMS, Rome Rome's municipal museum on the Capitoline Hill is the world's oldest national museum collection. The Museum was created in 1471 when Pope Sixtus IV donated his collection of

ancient bronzes to the Roman people. Since then the collection has grown to include Italian art, archaeology and coins. The Museum was fully opened to the public in 1734.

VATICAN MUSEUMS, Vatican City The museum of the popes was established in 1506 by Julius II when he put on display his collection of ancient Roman statues. Today the Museum is formed of fifty-four galleries showing off the treasures of the papal collection, including the famed ceiling of the Sistine Chapel, painted by Michelangelo between 1508 and 1512.

ROYAL ARMOURIES, London Records suggest that the Royal Armoury collection of weapons at the Tower of London received its first visitor by special permission in 1498. However, it was not until after the restoration in 1660 that the public were allowed to view the collection as a popular demonstration of the history and strength of the English monarchy. Today the extensive collection of weaponry is split between the Tower of London and a specially built museum in Leeds.

THE KUNSTMUSEUM, Basel This museum traces its origins back to the Amerbach Cabinet, an art collection created by Basilius Amerbach, which was bought by the city of Basel in 1661. This municipally owned collection was therefore the first public museum in the world. Today the Museum is the largest and most

important art collection in Switzerland, encompassing art from the fifteenth century to the present day.

THE PICTURE GALLERY, BODLEIAN LIBRARY, Oxford The Upper Reading Room of the Bodleian Library, built between 1613 and 1618, was originally a picture gallery, open to the public, housing portraits, cabinets of coins and medals, a chair made from the timber of Sir Francis Drake's ship *The Golden Hind*, and other curios. It therefore has a claim to being Britain's first public art gallery. By 1907 the gallery had been converted into a reading room and its contents dispersed to other parts of the Library and the Ashmolean Museum.

THE ASHMOLEAN MUSEUM, Oxford Elias Ashmole bequeathed his diverse collection (including the mantle of Pocahontas's father, Chief Powhatan/ Wahunsenacawh, and the stuffed body of the last dodo seen in Europe) to the University of Oxford. By 1683 the Museum was open to the public (it moved to its new site in 1894). It is therefore Britain's oldest public museum and the world's first university museum.

MUSÉE DES BEAUX-ARTS ET D'ARCHÉOLOGIE, Besançon France's oldest public art collection was founded in 1694 after the abbot of St Vincent, Jean-Baptiste Boisot, bequeathed his art collection to the Benedictines of the city. Boisot specified that the objects must be put on public display for two days every week, ensuring the collection remained a public resource.

MUSEUM COLLECTIONS
MANAGEMENT SYSTEMS

In order to keep a track of all the objects in a collection, museums have traditionally used a cataloguing system that gives each new item an accession number or code. For example, at the British Museum the most commonly used format is the year of accession, followed by the collection number, followed by the unique object number (and part number if required). The object number is a running number from the beginning to the end of the year. These codes are unique to each artefact and allow the museum to keep track of an object and its history in the collection. Ever since technology has allowed it, museums have been developing computerized collections management systems (CMS) that allow a much wider amount of information to be kept about each object; for example, its provenance, exhibition history and conservation reports.

Since the late 1960s and early 1970s a number of museums have worked together with IT professionals to develop new computerized cataloguing systems which can be constantly updated and changed with an object's latest location or conservation status. Today museum collections management systems are used by numerous departments in the organization to record details about each artefact in terms of administration, loan, exhibition, preservation and retrieval – aiding workflow and better management practices. In recent

years, with the growth of the Internet, more and more museums are making their catalogues available online. This has led to greater public engagement, as researchers and members of the public can now study an object and its history from the comfort of their desks.

UNUSUAL MUSEUM EXHIBITS

Museums are not all flower paintings and Greek statues; some exhibits are rather more visceral, as evidenced by the collection of unusual museum objects below:

SIR JOHN HEYDON'S HAND Nestled inside an ornate painted wooden box is a shrivelled brown hand, complete with horny fingernails, which once belonged to Sir John Heydon. The hand was cut off during a duel in 1600. Today it can be seen in Norwich Castle Museum's collection.

NOTEBOOK BOUND IN HUMAN SKIN Infamous murderer and graverobber William Burke was executed for his crimes in 1829 before being publicly dissected. The History of Surgery Museum in Edinburgh holds a notebook which is said to have been bound in Burke's skin.

SAMPLES OF TATTOOED SKIN The Wellcome Collection in London has one of the world's largest

collections of dried preserved sections of tattooed skin, with over 300 samples.

SHRUNKEN HEADS Among the University of Oxford's collections are a number of shrunken heads. Shuar communities living in tropical regions of Ecuador and Peru were excellent leather workers. They were known to practise headhunting their enemies. Through an elaborate process they would shrink down the skin of the captured head and carry it around the neck during a year-long ceremony to ensure the spirit of the enemy could no longer inflict any harm.

FROSTBITTEN FINGERS AND TOES Poor Major Michael 'Bronco' Lane lost his fingers and toes to frostbite during his ascent of Everest. Not one to let things go to waste, he donated them to the National Army Museum in London.

NUMEROUS PINS, BUTTONS AND SAFETY-PINS Why unusual, you say? Well, the 1,446 small items in this display at the Glore Psychiatric Museum in St Joseph, Missouri, were found in the stomach of a woman suffering from pica – the compulsive desire to swallow inedible objects.

MUSEUM TREASURES:
THE STAR-SPANGLED BANNER

On 14 September 1814 a group of American soldiers hoisted a huge 30 foot by 40 foot American flag over Fort McHenry in Baltimore to celebrate their victory over British forces. Francis Scott Key, on seeing the majestic flag fluttering in the wind, composed the poem 'The Defence of Fort M'Henry' which was later adapted to become the American national anthem. Lieutenant Colonel George Armistead kept the battle-torn flag as a family keepsake, and as the popularity of the patriotic new anthem grew he received more and more requests to put on show the flag that inspired it. Armistead dutifully acquiesced but unfortunately the flag became damaged due to repeated manhandling (one eager souvenir hunter even snipped out one of the stars). By 1907 it was in a poor state, so Armistead's ancestor first loaned, then gifted, the flag to the Smithsonian Institution in Washington DC on the proviso it was put on permanent public display. In 1998 the flag underwent extensive restoration, which took ten years to complete. Since then it has been exhibited in a special climate-controlled case, protecting the delicate iconic flag for generations to come.

VISITS TO SPONSORED MUSEUMS

The Department for Digital Culture, Media and Sport (DCMS) sponsors fifteen museums across England which provide free entry to their permanent collections. A total of 47.3 million people visited the sponsored museums in 2017–18:

MUSEUM	VISITORS
Tate Gallery Group*	8,165,704
British Museum, London	5,822,515
Science Museum Group†	5,325,039
National Gallery, London	5,050,020
Natural History Museum, London	4,712,656
Victoria and Albert, London	4,396,557
National Museums Liverpool‡	3,305,671
Royal Museums Greenwich	2,560,150
Imperial War Museums§	2,465,461
Royal Armouries, London	2,112,635
National Portrait Gallery, London	1,691,545
Horniman Museum, London	813,195
Wallace Collection, London	463,284
Sir John Soane's Museum, London	130,700
Geffrye Museum, London	114,906

* Tate Britain, London; Tate Modern, London; Tate Liverpool; Tate St Ives, Cornwall.
† Science Museum, London; National Railway Museum, York; Museum of Science and Industry, Manchester; National Science and Media Museum, Bradford; Locomotion, Shildon.
‡ International Slavery Museum; Lady Lever Art Gallery; Merseyside Maritime Museum; Museum of Liverpool; Sudley House; Walker Art Gallery; World Museum.
§ London, Manchester and Duxford.

THE LOUVRE ABU DHABI

In 2007 the United Arab Emirates (UAE) signed an agreement with France to develop a 'universal museum' in Abu Dhabi that would tell the story of the development of art and civilization. The agreement, worth over $1 billion, meant that a huge new museum could be created from nothing, through a partnership with French museums. The UAE could use the Louvre name for thirty years and the new museum would be furnished with over 300 loans from thirteen major French museums – including the Palace of Versailles, Musée d'Orsay and Centre Pompidou – during its first ten years. The impressive museum building was designed by Jean Nouvel, with a huge perforated metal domed roof, intended to cast myriad shadows on the interior as if the sun were streaming through a date palm frond. The museum was due to open in 2012, but the complexity of the design, coupled with the impact of the global recession, meant that it did not open until November 2017. One of the major challenges was to protect the artworks from the extreme heat; the galleries have been meticulously designed to ensure the temperature does not fluctuate. It opened with some notable artworks on loan from its French partners, including Whistler's depiction of his mother, Leonardo's *La belle ferronnière* and David's equestrian portrait of Napoleon, but perhaps the crowning glory is Leonardo's *Salvator Mundi*, which was acquired in 2017 for a record-breaking $450 million (*see p. 17*).

THE BRITISH MUSEUM

Robert Cotton (1571–1631) built up an astonishing number of important books and manuscripts over his lifetime, including the Lindisfarne Gospels, two copies of Magna Carta and a manuscript of Beowulf. This collection was augmented by his son and grandson before it was bequeathed to the nation on Sir John Cotton's death in 1702. In 1753 the British government bought another important manuscript collection, the Harley Manuscripts, for £10,000, a collection that was established by Robert Harley in 1704. This triumvirate of magnificent treasures was completed in 1753 when Sir Hans Sloane died and left his vast collection of over 71,000 objects to the nation. As a result the British government passed the British Museum Act, which established a national museum (the first of its kind in the world) with the three collections at its heart.

Montagu House in Bloomsbury, one of the finest private houses in the capital, was selected as a suitable venue for the museum. The gardens opened to the public in 1757, followed by the refurbished Montagu House, now known as the British Museum, in 1759. A group of trustees supervised the creation of the Museum. Although they were keen for it to be open to the public, they did not let visitors wander unfettered around the galleries but instead provided Museum officers to give guided tours. Entrance to the Museum was free but visitors had to apply for tickets, which were only granted to those deemed 'studious and

curious Persons'. The Museum was an immediate success, with about 12,000 visitors a year attending in its first few years of operation.

As the collection grew, more space was required. By 1808 the Townley Gallery was completed, with further wings added and improvements made throughout the nineteenth century. In 1802 the Museum acquired the Rosetta Stone, in 1805 the Townley collection of classical sculptures, and in 1816 the Parthenon sculptures (also known as the Elgin Marbles), augmenting the impressive and wide-ranging collection. By the 1880s the Museum was so full that it was necessary to create a separate museum in South Kensington for all the natural-history specimens; this became the Natural History Museum, which opened its doors in 1881. In

1973 the British Library was created and the Cotton Library and Harley Manuscript collection formed the basis of its collection. Until 1996 it was based at the round reading room within the British Museum, after which it moved to its own purpose-built building in King's Cross. Work started on the glass roof of the Queen Elizabeth II Great Court in 1999, resulting in the largest covered public square in Europe and massively increasing the space in the Museum. Today the British Museum is the sixth most popular museum in the world, welcoming over 6 million visitors from around the world every year.

MUSEUMS IN LITERATURE

The Goldfinch by DONNA TARTT – The central dilemma from this Pulitzer prize-winning novel occurs after teenaged protagonist Theo is caught up in a bomb attack on New York's Metropolitan Museum of Art. However, the painting he rescues from the rubble, *The Goldfinch* by Carel Fabritius, painted in 1654, is actually owned and displayed by the Mauritshuis in The Hague, Netherlands.

The Children's Book by A.S. BYATT A young runaway in Victorian Britain ends up at the South Kensington Museum (which later became the Victoria and Albert) where he sets up camp, sketching the Museum's many treasures.

'On Seeing the Elgin Marbles for the First Time' by JOHN KEATS This poem describes Keats's first encounter with the Elgin Marbles at the British Museum.

Wonderstruck by BRIAN SELZNICK – This wonderful children's book is told partly in words and partly in pictures. The narrative includes the dioramas at both the American Museum of Natural History and the Queens Museum of Art to evoke and inspire wonder.

The Silence of the Lambs by THOMAS HARRIS When FBI agent Clarice Starling needs to identify a moth pupa found on the body of a murder victim she takes it to the Smithsonian in Washington DC. It is identified as the black witch moth, a species which would not have naturally occurred where it was found, providing a vital clue as to the killer.

The Catcher in the Rye by J.D. SALINGER Holden Caulfield visits the American Museum of Natural History to re-experience his childhood memories of the place.

The Subtle Knife by PHILIP PULLMAN In her quest to understand 'dust', Lyra travels to Will's Oxford and visits the Pitt Rivers Museum, where she examines the eclectic collection.

MUSEUMS UNDER ATTACK

In times of conflict, museums are not immune to violence. During the English Civil War (1642–51) parliamentarian General Fairfax sent soldiers to guard the valuable collection of books and objects at the Bodleian Library to prevent plunder when the Royalist forces of Charles I abandoned Oxford. In World War II when London came under attack during the Blitz, many major museums sent their artworks to underground bunkers or remote country houses. Miraculously in Britain only one masterpiece owned by a London museum was lost, when Richard Wilson's *The Destruction of the Children of Niobe* was destroyed after a bomb hit the conservation studio in the West End where it was undergoing treatment. In recent years a number of shocking attacks have taken place on artworks in museums. In 2001 the Taliban attacked the National Museum in Kabul, taking pickaxes to over 2,750 ancient works of art which depicted living beings, stating that such images offended their idea of God. Also in 2001 the Taliban dynamited the ancient Buddhas of Bamiyan, which had been created at some point between the fourth and sixth centuries, hewn from the sandstone cliffs. The 35- and 53-metre statues were blown to pieces as the images were regarded as iconoclastic. In 2015 Islamic State fighters rampaged through Mosul's central museum in Iraq, using sledgehammers to destroy ancient statues and artworks, causing widespread condemnation of the attack on Iraq's cultural heritage.

MUSEUM TREASURES:
THE LEWIS CHESSMEN

The Lewis Chessmen were found near Uig on the Isle of Lewis in the Outer Hebrides c. 1831. Eighty-two pieces were acquired by the British Museum in 1832 and the remaining eleven pieces were obtained by the Society of Antiquities of Scotland in 1888. The pieces are thought to date from c. 1150–1200, at which time the Isle of Lewis was under Norwegian, not Scottish, control. The ninety-three pieces make up more than one chess set, so historians have suggested they may have been hidden for safekeeping by a Norwegian trader on the trade route from Scandinavia to Ireland. The beautifully carved pieces, some of which were originally dyed red, are thought to have been made in Trondheim, Norway, from walrus ivory and whales' teeth. Chess originated in India c. 500 BCE and spread to Europe from the Islamic world. These pieces have been adapted to represent contemporary medieval society, featuring kings, queens, bishops and knights. The majority of the chessmen are on show at the British Museum. Six pieces are on long-term loan to Lews Castle Museum and Archive project on Stornoway.

CURSED MUSEUM OBJECTS

There are many tales about the collecting of artefacts for museums in the past. Some stories, coupled with the provenance and the (perhaps coincidental) misfortunes that then followed the owners of a disputed artefact, have led to a number of objects being labelled as 'cursed'. Below is a summary of some supposedly cursed objects in museum collections (readers are reminded that, by their very nature, tales of curses are often exaggerated and embellished to enhance the cachet of an object and so should take the following with a large pinch of salt):

THE HOPE DIAMOND This astonishing large blue-tinged diamond was cut from the even larger Tavernier Blue diamond, first acquired in the seventeenth century by French gem merchant Jean-Baptiste Tavernier. The rumour goes that Tavernier obtained the diamond from a Hindu temple in India, where it served as an idol's giant eye and was said to be protected by a curse. The gem was sold to King Louis XIV, who died of gangrene; it then passed to Louis XVI and Marie-Antoinette, who ended their days under the guillotine. Numerous other owners suffered murders, suicides and disasters – all adding weight to the curse theory. In 1958 American Jeweller Harry Winston (who had owned the diamond for a number of years unscathed) donated the famous gem to the Smithsonian Institution in Washington DC, where it is one of the museum's

prime attractions, rumours of a curse no doubt adding to its allure.

THE UNLUCKY MUMMY In room 62, case 21, at the British Museum is displayed the beautifully decorated mummy-board of a female. Since it has been in the Museum's collection from 1889 it has been plagued by mysterious rumours of a curse, the flames of which have been fanned by sensational newspaper coverage and tall tales. It seems that before the mummy arrived at the Museum it passed through a number of owners; this being the Victorian era, when ghost stories were all the rage, every misfortune that hit anyone connected to the mummy became evidence of a curse. The rumours reached a peak in 1904 when journalist Bertram Fletcher Robinson wrote a story for the *Daily Express* entitled 'A Priestess of Death' which detailed various victims of the curse. Just three years later Robinson died suddenly aged just 36, seemingly confirming the mummy's malevolent nature. The Museum dismisses any talk of a curse as folklore, but nevertheless in recognition of the artefact's reputation has christened it the 'Unlucky Mummy'.

THOMAS BUSBY'S CHAIR In North Yorkshire in 1702 innkeeper and small-time crook Thomas Busby was sentenced to death for the brutal murder of his father-in-law and partner in crime, Daniel Auty. One version of the story says he was granted his final request to sit in his favourite chair at the inn to have a drink; as he was taken away to be hung from the gibbet

he cursed the chair. Stories soon began to stack up of people who had sat in the chair at the pub and later perished, including an unlucky chimney sweep who was murdered by his friend, and two RAF airmen who had dared each other to sit in the chair and later that night died in a car crash. In the mid-1970s the publican decided to hide the cursed chair in the cellar, but a deliveryman found it and sat down, later dying when his van careered off the road. This was the last straw: the chair was donated to Thirsk Museum in North Yorkshire where it has been displayed ever since, hung high on the wall so that nobody can sit in it and risk succumbing to the curse of Thomas Busby.

LOST MUSEUMS

Early museums were frequently brought into being by the efforts of one enthusiastic creator and as such their enduring existence was in part dependent on the fate of its founder. Unfortunately a number of doubtless fascinating collections became broken up and sold off, or absorbed by larger institutions, on the demise of their curator. Below are some examples of museums that have been lost:

JENKS MUSEUM AT BROWN UNIVERSITY In 1871 John Whipple Potter Jenks established the Jenks Museum of Natural History and Anthropology at

Brown University in Rhode Island, USA. The museum of ethnographic and natural-history specimens was not just a teaching collection but also served as a laboratory for students studying the burgeoning subject of biology. Jenks carefully curated the eclectic collection until his death in 1894, when he collapsed on the steps of the Museum building itself at Rhode Island Hall. In 1915 the Museum was put into storage as the space was needed for further classrooms; then in 1945 the University inexplicably sent ninety-two truckloads of the collection to the dump. A small number of artefacts survived and were dispersed to other local museums, but biologists are left mourning the loss of this once awe-inspiring collection.

WILLIAM BULLOCK'S EGYPTIAN HALL, London Showman and collector William Bullock opened up his first museum in London in 1809. As the collection grew, he moved into a building on Piccadilly styled as an Egyptian temple (the first Egyptian-style building in the UK). Quite the innovator, Bullock

displayed his collection of 32,000 ethnographic and natural history specimens with detailed descriptions. Visitors were charged 1 shilling for entry to the main museum and another shilling to enter the Pantherion — a space set out as a tropical forest in which animals were displayed in mock-ups of their natural environment. Bullock broke up and sold his permanent collection in 1819. The hall continued to host visiting exhibitions until it was demolished in 1905.

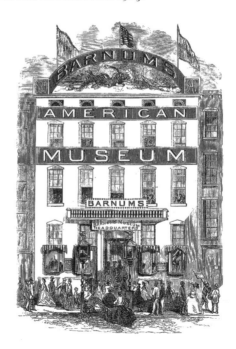

SCUDDERS AMERICAN MUSEUM, New York John Scudder opened his Museum in 1810 and a couple of years later moved the display to Manhattan's former poorhouse. The esoteric collection included such delights as an 18-foot snake and the supposed bedsheets of Mary, Queen of Scots. The Museum proved very popular and relocated to Broadway and Ann Street, staying open until 9 p.m. – so, for a small fee, visitors could peruse the collection by candlelight. Famous showman P.T. Barnum was so impressed with the Museum that he bought it in 1841, transforming it into a spectacle in which alongside the artefacts he displayed live human exhibits, such as conjoined twins Chang and Eng. Regrettably the Museum and its contents burned down in 1865.

MUSEO KIRCHERIANO, Rome Athanasius Kircher (1601–1680) was a Jesuit polymath with interests in exploration, language, magnetism and Egyptology (to name but a few). Thanks to a vast network of Jesuit missionaries, Kircher was able to disseminate the latest knowledge from scholars around the globe, writing numerous books and pamphlets sharing the latest theories on everything

from volcanology to hieroglyphics. Kircher was one of the first to create a museum of natural history, which was housed at the Collegio Romano in Rome. Alongside natural-history specimens, such as a lizard encased in amber, were a host of curiosities, including talking statues, an Egyptian obelisk and magic lanterns. The Museum very much reflected Kircher's personality and interests. Consequently, on his death it went into decline and was broken up.

JOHN HEAVISIDE'S MUSEUM, London Surgeon Extraordinary to King George III, John Heaviside opened a museum in his home at 14 Hanover Square in London, in 1793. Heaviside used an inheritance to purchase an existing anatomical collection created by fellow surgeon Henry Watson, which he opened for 'respectable gentlemen' every Friday evening. The collection was neatly arranged with anatomical samples in glass jars plus minerals, fossils and insects. The

Museum was broken up and sold on Heaviside's death in 1828, some of it ending up in the collection of the Hunterian Museum.

St George's Museum, Sheffield In 1875 celebrated art critic John Ruskin opened the St George's Museum in Walkley, Sheffield. The collection of watercolours, prints, minerals, illustrated books and coins was intended as a resource to inspire the steel workers of Sheffield – a group of artisans Ruskin believed to be the best in the world. The Museum was free to visit but was hampered by its small building, making the collection cramped. Ruskin attempted to raise public subscription to build larger premises but this failed. In 1890, as Ruskin's health faltered, he accepted an offer from the Corporation of Sheffield to move the entire collection to a building in Meersbrook, where it was renamed The Ruskin Museum. This version of the Museum closed in 1953 and the items went into storage. In 2001 the collection was revived when it was moved to the new Millennium Gallery complex in Sheffield city centre, where it can be enjoyed today in the Ruskin Gallery.

THE FATBERG

In September 2017 the largest fatberg ever discovered was found by sewer workers to be blocking the drains in Whitechapel, London. The fatberg, made from grease, congealed oil, wet wipes and other sanitary detritus, was an astonishing 250 metres long and weighed 130 tonnes. News of the fatberg spread around the world, its enormous size and epic removal seeming to sum up our modern disposable culture where all manner of items are flushed down our toilets. The Museum of London decided that a sample of the fatberg should go on display in the Museum to reflect the problems caused by modern life in the ever-expanding capital. However, concerns were raised over the potential toxicity of the slice of fatberg and so specialist conservators worked to stabilize and safely display the gloriously gross lump. Curators wore full protective clothing at all times when handling the fatberg and ensured the samples were stored within three sealed boxes to prevent any nasty smells escaping. Two small slices of fatberg went on display as a special exhibition at the Museum of London in February 2018; providing the samples do not degrade too much, they may later be considered for permanent display. Readers will be relieved to know that the rest of the massive fatberg was broken up by Thames Water; much of it was drained of water and converted to biodiesel, allowing it to be safely reused.

THE LOUVRE

The world's largest art museum today houses numerous major works of art, including arguably the most famous painting in the world – the *Mona Lisa*. The building's origins date back to the early medieval period. In 1190 King Philippe Auguste ordered the building of a fortified garrison on the outskirts of Paris. It became an important strategic location. By the reign of François I (1515–47) the kings of France desired a residence in Paris in order to maintain order; the Louvre was selected as the perfect site. The chateau was rebuilt and completed under the reign of Henri II (1547–59), and it became the Parisian home of the French monarchs. Louis XIV preferred the Palace of Versailles as his favoured residence, and so from 1682 the Louvre Palace became the location for the display of the royal art collection.

During the French Revolution it was decided the Louvre Palace should become a national museum.

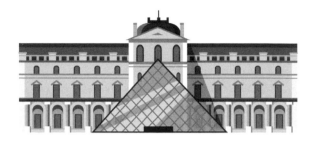

The reclaiming of this decadent royal palace to house a national collection was seen as a perfect representation of the Revolution's egalitarian ideals. It opened on 10 August 1793 with 537 artworks, most of which had been confiscated from the royal collection, the Church and the nobility. During Napoleon's reign he modestly renamed the museum Musée Napoleon and had the *Mona Lisa* hung in his bedroom. The collection continued to grow. In 1983 President François Mitterrand decided that the finance ministry, which had inhabited part of the building, would be moved out so as to give over the entire complex to the museum. To cement the refurbishment, a now iconic glass pyramid, designed by I.M. Pei, was built over the entrance and inaugurated in 1988. Below are a number of fascinating facts about the Louvre:

Established	1793
Number of works	380,000[*]
Number of paintings	7,500[†]
Extent of galleries	72,735 square metres

[*] If every work were on display, you might be able to see them all if you spent 100 days visiting the museum, with just thirty seconds for each object.
[†] 66 per cent of which are by French artists.

Number of employees	2,100
Visitors in 2018	10.2 million
Visitors per minute	40
Height of pyramid	21 metres
Departments	Near Eastern Antiquities; Egyptian Antiquities; Greek, Etruscan and Roman Antiquities; Islamic Art; Sculptures; Decorative Arts; Paintings; Prints and Drawings.

THE BEETLES THAT HELP TO PREPARE NATURAL-HISTORY SPECIMENS

When a natural-history museum gets hold of a new specimen a great deal of work goes into preparing it for display. All those rows of clean skeletons were once covered in flesh, and picking the bones clean is quite some job. Numerous methods are employed to prepare a skeleton, including boiling the bones in water until the flesh drops off; burying the bones in elephant dung or compost and leaving them for months until the flesh has rotted away; or packing the bones in a barrel full of water and maggots until the putrid flesh has been picked clean away. However, each of these rather gruesome methods has its drawbacks, from weakening the bones to simply taking too long.

Since the late Victorian period an alternate method has been practised and perfected in America which involves employing colonies of the hide beetle (*Dermestes maculatus*) to eat away any flesh left on bones. No one is quite sure who first used the beetles in a museum setting but one likely candidate is Charles Dean Bunker, who started work at the Kansas University Biodiversity Institute and Natural History Museum in 1895. Bunker's influential use of dermestid beetles for the cleaning of animal skeletons saw the practice spread to other institutions across America, and today numerous natural-history museums keep a colony on hand. To get the most from a beetle colony the specimen should first be air-dried before being placed in a sealed vivarium along with the bugs. Keeping them at a constant temperature of about 21 degrees Celsius and ensuring the correct level of humidity will maximize the beetles' efficiency, meaning that they could completely strip a mouse carcass in the space of about an hour. The one drawback of these helpful museum bugs is that their voracious appetite means that should they escape into the wider collection they would pose a great threat to the numerous animal specimens on display. To this end, most museums that keep colonies of dermestid beetles

behind the scenes ensure they smear Vaseline on their vivaria walls to prevent any scaling the sides, and place sticky bug traps across the doors to ensure that escapees never make it out of conservation.

FREE NATIONAL MUSEUMS

Free visits to national museums were introduced across Britain by the Labour government in 2001 in an effort to open up the nation's cultural heritage to a wider cross section of society. The scheme had a very positive effect on visitor numbers, with figures from the Department for Digital, Culture, Media and Sport (DCMS) showing that between 2000 and 2010 visitor numbers to national museums increased by 51 per cent. The impact on visitor numbers was especially strong in those museums which formerly charged – visitor numbers rose by 269 per cent between 2000/01 and 2010/11 at National Museums Liverpool; by 204 per cent at the National Maritime Museum; by 184 per cent at the National History Museum; and by 180 per cent at the Victoria and Albert Museum. The impact of free museums was especially noticeable for children, with 36 per cent more visits 2000/01 to 2010/11; among ethnic minorities, who in the same period saw visitor numbers increase 177.5 per cent; and for those from lower socio-economic groups. To date over fifty national museums across the UK are free to visit.

THE MUSEUM OF BROKEN RELATIONSHIPS

In 2006 Croatian artists Olinka Vištica and Dražen Grubišić broke up. As they sorted through their shared belongings, now destined for the dustbin, they realized that these objects told a story of their love affair. The idea for a museum dedicated to discarded love tokens was born. The first Museum of Broken Relationships was established in Zagreb and was furnished with mementoes of failed relationships by members of the public, eager to exorcize their ghosts and share their heartbreak. The Museum was so successful it spawned a second permanent home in Los Angeles, which opened in 2016, a number of travelling exhibitions and an online presence where people can upload their items and memories of relationships past. Each item is displayed with a short anonymous description. Some examples include:

* An old Nokia mobile phone with the caption: 'It lasted 300 days too long. He gave me his mobile phone so I couldn't call him anymore.'
* A toaster with the caption: 'I took the toaster. How are you going to toast anything now?'
* A pair of silicone breast implants with the caption: 'I finally decided to have the implants removed to reclaim my own natural body, and to close the door on any leftover influence that ex had on my life. What a beautiful send-off for these two lumps of silicone that caused me so much pain.'

- A bottle filled with cigarette butts with the caption: 'We said that we would quit smoking after this bottle has been filled.'
- A diamond ring with the caption: 's(he) be(lie)ve(d)'.

OLDEST MUSEUM OBJECTS

Often the oldest objects in museum collections may look rather humble, but their appearance belies their amazing longevity and awe-inspiring stories. Below are listed some of the oldest artefacts in museum collections around the world:

OLDUVAI CHOPPING TOOL This stone chopping tool is the oldest human-made object in the BRITISH MUSEUM's collection. The tool, which would have been used for cutting plants, food and bones, dates back 1.8 million years and originates from the Stone Age site at Olduvai Gorge in Tanzania, where evidence of the earliest humans has been found. The tool was excavated by the East Africa Archaeological Expedition led by Louis Leakey in 1931 and acquired by the Museum in 1934.

MOON ROCK A piece of moon rock formed some 3.8 billion years ago is on display at the NATIONAL AIR AND SPACE MUSEUM in Washington DC. The basalt rock is one of the few moon rocks in the world

that visitors are actually allowed to touch. The rock was harvested from the surface of the moon in 1972 during the Apollo 17 mission. It was acquired by the Museum in 1976.

THE EARLIEST KNOWN COINS Coins originated in Asia Minor in c.700 BCE. The Lydians minted the world's first true coins from electrum, a natural variable alloy of gold and silver. The Lydian one-third stater, or trite, featuring the image of a roaring lion's head, is the first coin, an example of which can be seen at the FITZWILLIAM MUSEUM in Cambridge.

THE VENUS OF HOHLE FELS The earliest known figurine with a human form was discovered in a cave known as Hohle Fels ('Hollow Rock' in Swabian German) near Schelklingen in south-west Germany in 2008. The figurine, carved from mammoth ivory, dates back to the Upper Paleolithic period some 40,000 years ago. It can be seen at the PREHISTORIC MUSEUM OF BLAUBEUREN.

THE WORLD'S OLDEST STONE MASKS Stone masks dating back 9,000 years to the start of civilization are on display at Jerusalem's ISRAEL MUSEUM. Archaeologists think the masks were created to represent dead ancestors and reveal the beliefs of the earliest farmers in the Judean Hills region.

THE OLDEST HISTORICAL DOCUMENT IN THE WORLD The Narmer Palette is an Ancient Egyptian tablet dating from around the thirty-first century BCE,

which with early hieroglyphics depicts the unification of Upper and Lower Egypt under King Narmer (or Menes), the first king to rule over the whole of Egypt. The 64 cm schist palette, decorated on both sides, was discovered in 1897/8. Today it is housed at Cairo's EGYPTIAN MUSEUM.

THE OLDEST LEATHER SHOE The oldest known leather shoe was excavated from a cave in Armenia in 2008. The shoe, fashioned from a single piece of leather stitched into a moccasin-like form, dates back 5,500 years. The shoe is on display at the HISTORY MUSEUM OF ARMENIA in Yerevan, Armenia.

THE OLDEST EXAMPLE OF MONUMENTAL ART The
Shigir Idol is a wooden statue with a carved face. It
was discovered in a peat bog in Siberia in 1894. The
statue was originally 5.3 metres tall but part of it went
missing during the Soviet era and today it stands at
2.8 metres. Recent radiocarbon dating has revealed
that the statue is at least 11,000 years old. The statue
can be seen at SVERDLOVSK HISTORY MUSEUM in
Yekaterinburg, Russia.

DIPPY

The iconic cast of a diplodocus skeleton, fondly known
as 'Dippy', was retired from its starring position
in the Natural History Museum's entrance hall in
2017. Dippy first went on display at London's Natural
History Museum in 1905, immediately becoming a
firm favourite with visitors. Diplodocus fossils were
first described as a new type of dinosaur in 1878 by
Professor Othniel C. Marsh of Yale University. When
railroad workers unearthed an enormous specimen
in 1898 in Wyoming, USA, Scottish businessman
and philanthropist Andrew Carnegie determined to
acquire the skeleton for his Pittsburgh museum. As
the specimen was being assembled at the museum,
palaeontologists noticed in this skeleton subtle differ-
ences from previous diplodocus fossils and named the
new subspecies *Diplodocus carnegii* in Carnegie's honour.

When King Edward VII saw a sketch of the enormous Pittsburgh specimen at Carnegie's castle he expressed his admiration. As a consequence Carnegie set about creating a cast of the fossil* to be given to the Natural History Museum in London. The impressive 292-bone replica arrived in London in thirty-six packing cases; it was carefully reassembled and displayed in the then Reptile Gallery. Originally Dippy's head was shown drooping down to the ground, but as researchers' understanding of diplodocus increased it was moved into a more upright position; likewise the tail originally ran along the floor but in 1993 was changed to curve upwards over visitors' heads. Dippy was moved to Hintze Hall in 1979, becoming the first specimen to greet visitors as they entered the Museum.

After 112 years on the job Dippy was retired from this role, to be replaced by a 25 metre-long skeleton of a young Blue Whale, which had been discovered stranded on a sandbank in Wexford Harbour, Ireland, in 1891. The beloved Dippy will not disappear entirely from view; it will spend the next three years touring some of Britain's major regional museums, allowing even more visitors to engage with this amazing specimen.

* Ultimately ten casts of the diplodocus were made and gifted to museums around the world, including in Paris, Berlin and Moscow.

MUSEUM TREASURES:
THE GUNDESTRUP CAULDRON

In 1891 in a peat bog near Gundestrup in Himmerland, Denmark, an astonishing ornate silver cauldron was unearthed. Historians think the cauldron had been plunged into the bog as an offering, its ornate side panels having been first removed and stashed in the bottom of the vessel. The cauldron is thought to date from between the first and second centuries BCE, making it one of the largest surviving pieces of Iron Age silverwork from the early Roman period. The embossed panels depict a variety of beasts, including deer, elephants, boar, horses, dogs and numerous human and god-like figures which have fascinated and confused scholars in equal measure as they try to establish where the cauldron originated. The cauldron is probably Celtic and yet historians are divided on whether it originated in Thrace or Gaul, the design, metallurgy and mythology not clearly pointing to one location. The reassembled cauldron (missing part of the rim and one of the decorative panels) is on display at the National Museum of Denmark in Copenhagen.

THE NONSEUM

The Nonseum was opened in Herrnbaumgarten, Austria, by a group of local artists in 1994 to collect and display failed inventions and useless items, and to raise a smile. As part of the small museum they have an unrivalled selection of single socks – a plea on their website urges readers to send in their orphaned socks to add to the ever-growing collection – plus a display of empty boxes containing historical buttonholes. The mainstay of the museum is their selection of failed (or rather useless) inventions, such as: bowls with plug-holes, a see-through suitcase for nudists, a spoon with holes in for dieters, a padded rolling pin (to hit people without hurting them) and transparent playing cards.

THE WHITE HOUSE
AND MUSEUM LOANS

The White House holds some 500 paintings in its official collection. Each time a new president assumes office fresh pictures are selected by the curators to adorn the walls of 1600 Pennsylvania Avenue. Along-side paintings from the White House collection the new First Family may request the loan of favourite pictures from museums and galleries. Traditionally the Smithsonian and the National Gallery of Art, both located in Washington DC, have provided the

majority of loaned artworks, but it is not unknown for paintings to be sourced from across the country. For example, Michelle Obama selected two Edward Hopper paintings to hang in the Oval Office which were temporarily loaned from the Whitney Museum of American Art in New York. In January 2018 Donald Trump requested that the Guggenheim loan him Van Gogh's *Landscape with Snow* (1888). The Museum's chief curator Nancy Spector politely refused the request and instead offered *America* by Maurizio Cattelan – a fully functioning solid gold toilet.

Other notable museum loans to the White House include:

1961 Jackie Kennedy borrowed *The Smoker* by Eugène Delacroix from the Smithsonian to hang in the Red Room.

1965 President Johnson borrowed Jackson Pollock's *Cathedral* (1947) from Dallas Museum of Art.

1994 President Clinton borrowed Scott Burton's sculpture *Granite Settee* (1982/3) from Dallas Museum of Art.

2009 President Obama was loaned Thomas Hill's *View of the Yosemite Valley* (1865) by the New York Historical Society for his inaugural luncheon.

NEW SPECIES DISCOVERED
IN MUSEUM COLLECTIONS

Most new species are discovered by scientists working in the field, but occasionally researchers working with existing natural-history collections find an old specimen that may have been mislabelled or misidentified, which can lead to a new discovery. Below are some examples of new species found in museum collections:

A GOLDEN BAT In 2014 researchers announced they had discovered a new species of bat, which they named *Myotis midastactus* after the legendary King Midas in a nod to the bat's bright golden coat. Over 100 subspecies of *Myotis* (or mouse-eared bats) exist across the globe. To establish that this really was a new species the researchers compared twenty-seven different specimens of South American bats kept in museums across America and Brazil. This confirmed that the golden bat was a distinct species native to Bolivia.

THE ZEBRA-LIKE RINGLET BUTTERFLY London's Natural History Museum has over 9 million moths and butterflies in its collections, so it is unsurprising that it harbours some new species. The large stripy butterfly was collected in Peru in 1903 but misidentified until a curator confirmed it as a new species, *Splendeuptychia mercedes*, in 2011.

OLINGUITO In 2013 an American team announced they had found the first new carnivore discovered in the western hemisphere for thirty-five years, the olinguito. This elusive new member of the *Procyonidae family* is native to the cloud forests of Ecuador and Colombia. It was identified from DNA taken from a number of old museum specimens.

THE PIKE CICHLID This fish species (*Crenicichla monicae*) was first collected in the Amazon basin by Alfred Russel Wallace, but unfortunately the ship carrying the specimen sank in 1852. Swedish ichthyologist Sven Kullander used Wallace's sketch of the lost fish to identify the species from a specimen in the Swedish Natural History Museum which had been found in the 1920s.

BRYAN'S SHEARWATER This seabird is the first new bird species discovered in America for nearly forty years. The museum specimen was collected in Hawaii in 1963 but mistakenly thought to be a little shearwater (*Puffinus assimilis*). However, researchers tested its DNA in 2011 and discovered it was a new, even smaller, species of shearwater, naming it *Puffinus bryani.* In 2015 ornithologists were delighted to find live specimens in a small breeding colony on the Ogasawara Islands in Japan.

THE METROPOLITAN MUSEUM OF ART

In 1866 a group of American businessmen, financiers and philanthropists met in Paris and, led by lawyer John Jay, agreed to create a national gallery of art for the American people. Once back in America, Jay became president of the Union League Club of New York and soon began fund-raising to make the idea a reality. By 13 April 1870 the Museum had become incorporated. The statute stipulated that it should have 'the purpose of encouraging and developing the study of fine arts and the application of fine art to manufactures and practical life'. The Museum initially opened in the Dodworth Building at 681 Fifth Avenue and acquired its first object – a Roman sarcophagus uncovered in Tarsus (modern-day Turkey) in 1863 and gifted to the Museum by the American vice consul of Tarsus.

The Museum soon outgrew its first home, where-upon it moved temporarily to Douglas Mansion at 128 West 14th Street while the building of its permanent home overlooking Central Park on 5th Avenue was completed. In 1871 the collection was boosted by the acquisition of 174 European paintings by luminaries such as Van Dyck and Nicolas Poussin. In 1880 the Gothic Revival building on 5th Avenue opened to the public. The Museum continued to grow, with paintings and antiquities bolstering the collection. From 1888 there was further expansion of the building, including its now famous Beaux-Arts facade and Great Hall, which opened in 1902.

In the twentieth century the Museum continued to build on its growing world-class collection, including collecting five of the thirty-four artworks ascribed to Dutch master Johannes Vermeer. The Met is also especially strong on Egyptian artefacts, holding over 26,000 Ancient Egyptian objects, representing the largest haul of Egyptian art outside of Cairo. Today the original Museum building is surrounded on all sides by more modern wings added to aid expansion over the years, although a portion of the original west facade can be espied from the Robert Lehman Wing. The Museum now has over 2 million square feet of gallery space and boasts over 2 million objects and works of art, cementing its position as America's most prestigious art gallery.

THE MYSTERY OF THE SPINNING STATUETTE

In 2013 Manchester Museum began to suspect ancient magic may be at work after a 3,800-year-old Egyptian statue began mysteriously rotating within its glass case. The 10-inch statuette depicts a civil servant Neb-Senu, whose small likeness would have been buried with his mummified remains in order to act as a vessel for his spirit, should his mummy ever be destroyed. The statue was gifted to the Museum in 1933, after local mill owner Annie Barlow sponsored an archaeological

dig in Egypt, and has been on display ever since. However, recently curators noticed that the statuette was slowly rotating. Fascinated by the mystery, curator Campbell Price set up a camera in an effort to catch the movement and was delighted to find that the time-lapse footage revealed Neb-Senu slowly rotating 180 degrees. As is customary these days, the video was posted online and soon went viral, sparking intense media attention and causing visitors to flock to see the magical statue. Theories abounded as to the cause of its movement – the more supernatural the better – but ultimately experts came to a rather more mundane conclusion. By placing motion sensors under the case, researchers were able to ascertain that the rumble of heavy traffic from the nearby Oxford Road was causing the statuette to move, its convex base making it more susceptible to vibration and movement than its flat-based fellows. Once the mystery had been solved, curators placed a special membrane on the base of Neb-Senu to prevent his spinning once and for all.

DANGEROUS MUSEUM OBJECTS

Museum curators do not just collect the benign and the beautiful; many museums have objects lurking in their collections which could do serious harm:

THE DRAGON CHAIR The Wellcome Collection in London holds a rare wooden dragon chair (1701–1900) from China. The ornate carved chair has twelve razor-sharp blades across the seat, arms and foot rest, giving it the appearance of a mode of torture. However, in reality the chair was made for Chinese mediums known as *tangki*, who by sitting safely in the chair revealed the power of God over the flesh.

MARIE CURIE'S PIEZOELECTRIC DEVICE When Marie Curie was on a lecture tour of America in 1921 she presented the College of Physicians of Philadelphia with one of her husband's piezoelectric devices – a machine for measuring radioactivity. The machine was displayed at the college's Mütter Museum for many years until a visiting scientist, knowing the history of the Curies' radioactive lab, suggested they check it with a Geiger counter. The results showed that the device was indeed radioactive. Although this would have posed no threat to Museum visitors, it was immediately pulled from show and thoroughly decontaminated.

CYANIDE AMPOULE The Imperial War Museum in London holds in its collection a glass ampoule

containing cyanide, which was hidden inside a German bullet casing. Secret agents were issued with cyanide so that they might commit suicide before they spilled any secrets should they be caught by the enemy.

POISON DART FROG Inside the Aquarium at the Horniman Museum in South London resides a living blue poison frog (*Dendrobates tinctorius*). This frog, native to South America, produces a highly toxic poison, with which indigenous tribes used to tip their hunting arrows.

VIKING AXES The National Museum of Denmark in Copenhagen holds an impressive collection of Viking axes. Analysis of the collection has shown that many of them would have been used as weapons. These axes would have had a lightweight iron head and a wooden shaft up to 1 metre in length, allowing them to be wielded with two hands. Archaeological evidence indicates that such axes were the weapon of choice for Danish Vikings.

TOP HAT The expression 'mad as a hatter' derives from the mercury salts used in the manufacture of hats, which slowly poisoned the workers. The Victoria and Albert Museum in London displays a number of Victorian beaver felt top hats which contain mercury salts. Conservators have worked to make the hats safe for display by steaming them.

MUSEUM TREASURES:
THE ROSETTA STONE

This piece of broken stone slab played a vital role in helping historians decipher hieroglyphics. The black granite stone fragment, which stands at 112 cm tall, was uncovered close to the town of Rosetta near Alexandria in Egypt by French soldiers in Napoleon's army in 1799. After the French surrendered Egypt to Britain in 1801 the Rosetta Stone was transported back to England to become part of the British Museum's burgeoning collection. Experts examining the stone realized that uniquely the stone displayed the royal decree issued by Ptolemy V (210–181 BCE) in three separate languages – hieroglyphs, demotic and Ancient Greek. At this point no one could read hieroglyphics. However, scholars were familiar with Ancient Greek and this allowed them to finally decipher the code of hieroglyphics, vastly opening up the scope of

Egyptology. Thomas Young was the first to begin deciphering the hieroglyphics in 1814, but he made limited progress. Then French scholar Jean-François Champollion published a paper, in 1822, which revealed that the hieroglyphs recorded the sound of the Egyptian language; this resulted in his 1824 breakthrough when he was finally able to translate the inscription fully.

The Rosetta Stone has been on display at the British Museum since its arrival in 1802, barring the two years it spent 50 feet underground in the Post Office Railway at Holborn from 1917 to protect it from German bombing raids.

COLLECTION MANAGEMENT

The objects in the UK's national museums are an asset of great value held in trust by institutions on behalf of the nation. Museum collections serve as depositories for countless historical objects and natural-history specimens, providing a wealth of information for researchers. However, a very small proportion of what is collected can be on show at any one time. This presents a huge problem for museums, which often struggle to manage and preserve their unwieldy, and ever-growing, collections. Debate has raged in the museum sector over how to manage active collections and the ethics of disposal. To put the problem in context, a 2003 report by the National Museum Directors' Conference revealed that

- the British Museum holds over 2 million artefacts from archaeological excavations;
- the National Museum of Scotland has over 750,000 archaeological objects;
- the Museum of London holds 250,000 archaeological finds and over 140,000 boxes full of bulk finds from London.

These millions of archaeological specimens are of huge value to the archaeological community. However, storing, processing and preserving them is a costly and time-consuming business. Museum collections need to keep growing – acquiring new objects to fill gaps in the collection or to preserve more recent technological

advances – but with finite space and finance this is problematic. Some institutions have come up with novel methods to address the problem. For example, the Kimbell Art Museum in Fort Worth, Texas, does not strive for a historically complete art collection; every time it acquires a new work of art it sells off another item from the collection, ensuring a one-in, one-out policy. Other solutions put forward are: digitize documents, photographs and prints so that the originals can be disposed of; sell off valuable objects to other institutions, thereby keeping them in the public sphere; transfer objects to more relevant collections. These sorts of ethical dilemmas faced by our national museums with regard to collection management are heightened by horror stories of museums that have disposed of items only to later realize their value. For example in 1949 the V & A decided to sell off at auction a set of eighteenth-century wooden chairs it thought were nineteenth-century copies. The chairs were bought by the king of Libya, who had them broken up and remade into stools and frames for mirrors. It was only later that researchers discovered that these were not just any old eighteenth-century chairs but had in fact been commissioned by Venetian Doge Paolo Renier (1710–1779), vastly multiplying their value.

MOST VISITED MUSEUMS BY REGION

Visit England annually compiles *The Annual Survey of Visits to Visitor Attractions*, which lists the most popular visitor attractions by region. These figures show the top results for each region for 'museums and art galleries' in 2017:

MUSEUM/GALLERY	REGION	VISITORS	
Wollaton Hall and Park	East Midlands	295,078	*free*
National Space Centre	East Midlands	301,096	*paid*
Fitzwilliam Museum	East	397,169	*free*
Lanman Museum	East	500,000	*paid*
Great North Museum	North East	486,711	*free*
Beamish	North East	761,655	*paid*
Merseyside Maritime Museum	North West	922,503	*free*
Manchester United Museum	North West	332,131	*paid*
Ashmolean Museum	South East	937,568	*free*
Mary Rose	South East	364,295	*paid*
Royal Albert Memorial Museum	South West	252,662	*free*
Roman Baths, Bath	South West	1,318,976	*paid*
Birmingham Museum & Art Gallery	West Midlands	602,634	*free*
Black Country Living Museum	West Midlands	332,717	*paid*

| Museums Sheffield: Millennium Gallery | Yorkshire & Humber | 723,128 | *free* |
| Lotherton Hall & Gardens | Yorkshire & Humber | 415,611 | *paid* |

Eight of the top ten most visited free attractions of all categories in England in 2017 were museums, proving our enduring love affair with the country's cultural heritage.

WAXWORK MUSEUMS

The tradition of making wax models of notable figures has its basis in European royalty, who from the medieval period used wax effigies of deceased royals as part of the funeral procession. Following burial the lifelike wax figures would be displayed in the church and the public would pay to view them. The museum at Westminster Abbey holds a number of these effigies, including the model made of Kings Charles II on his death on 1685. In the eighteenth century wax models of living royalty had become popular. In France court artist Antoine Benoist toured his exhibition of forty-three waxworks of the luminaries of the French court. A similar collection of waxwork models of the English court was displayed in Fleet Street, London, in 1711.

However, it was Madame Tussaud who truly popularized the phenomenon. Marie Grosholtz was born in France in 1761 and later moved to Switzerland with her mother, who worked for noted physician Philippe Curtius. Curtius was in the habit of making wax casts and models of the human body and it was from him that Marie learnt the skills, adapting the medical models to create lifelike scale waxworks of notable figures, such as Voltaire. Marie's talent was noticed by the French court and she was invited to Versailles to act as art tutor for the king's sister, Madame Elizabeth. Unfortunately Marie was soon caught up in the horror of the French Revolution and was put to work making wax casts of the heads of victims of the guillotine,

which were then paraded through town as a warning to all. Marie even took casts of her own former employers King Louis XVI and his wife Marie Antoinette after their execution.

In 1795 Marie married François Tussaud and became Madame Tussaud, touring her waxworks around Europe. However, by 1802 François had left his wife and two young sons and Marie moved to London, where she used her skills to open and furnish a waxwork museum. The museum was immediately popular with celebrities such as the Duke of Wellington, who paid a visit – no doubt to look upon his own likeness. Marie's most gruesome models, such as the death masks of the French royals and notorious criminals, were to be found in the 'Chamber of Horrors', which visitors paid extra to enter. Today Madame Tussaud's is a worldwide brand with museums around the globe, their enduring popularity likely in part due to the public's eternal urge to get up close to their idols, albeit only in wax form. In 2017 the waxwork museum The Hall of Presidents and First Ladies, in Gettysburg, Pennsylvania, closed down after sixty years and the contents sold off. The wax model of Abraham Lincoln made the most at auction, going for $8,500, with George Washington making a tidy $5,100.

TOP TEN MOST POPULAR
EXHIBITIONS IN LONDON

Every year *The Art Newspaper* collates visitor figures for the most popular exhibitions in museums and galleries across the globe. London is home to some of the most renowned and popular museums in the world. In 2018 the most popular paid-for exhibitions in London were:

	EXHIBITION	VISITORS (*day/total*)
1.	*250th Summer Exhibition*, Royal Academy of Arts	4,296/296,442
2.	*Charles I: King and Collector*, Royal Academy of Arts	3,250/256,789
3.	*Picasso 1932: Love, Fame, Tragedy*, Tate Modern	2,802/521,080
4.	*Modigliani*, Tate Modern	629/336,469
5.	*Oceania*, Royal Academy of Arts	1,857/135,555
6.	*Frida Kahlo: Making Her Self Up*, Victoria and Albert	1,823/284,420
7.	*Monet and Architecture*, National Gallery	1,702/190,626
8.	*Basquiat: Boom for Real*, Barbican Art Galleries	1,652/209,835
9.	*Andreas Gursky*, Hayward Gallery	1,621/122,468
10.	*Dalí/Duchamp*, Royal Academy of Arts	1,410/121,242

The Royal Academy had a record-breaking year in 2018, with 1.6 million visitors, up more than half a million visitors on the previous year.

THE DARWIN CENTRE

In 2009 London's Natural History Museum opened the Darwin Centre to the public. This space is designed to hold the Museum's millions of natural-history specimens and allows the public to observe its scientists at work in their laboratories. Below are some facts about the Darwin Centre:

Cost	£78 million
Designer	C.F. Møller
Insect specimens	17 million
Plant specimens	3 million
Glass cabinets	3.3 km
Number of scientists at work	200
Laboratory space	1,040 sq. metres

The specimens are stored in an eight-storey, 65-metre-long 'cocoon' – the largest sprayed-concrete curved structure in Europe. The centre also includes a 12-metre climate-change wall revealing the effects of climate change around the world through multimedia displays.

DISPOSAL OF OBJECTS

Museums must be sustainable and this often means facing tough decisions about the scope and size of a collection. Storing endless objects is costly, and finding the space and time to properly catalogue extensive collections can be a Sisyphean task (*see p. 104*). As a result many museums need to consider disposing of elements of their collections – a situation fraught with controversy, as by their very definition museums seek to preserve and promote our national heritage. To help museums tackle this dilemma the Museums Association (MA) has created an advisory document 'The Disposal Toolkit' on how to manage the disposal of objects. The MA recommends selecting items for potential disposal according to the following criteria:

- Items that fall outside the core collection as defined by a musem's collections development policy.
- Duplicate items.
- Underused items.
- Items for which the museum is unable to provide adequate care or curation.
- Items that are damaged or have deteriorated beyond the museum's ability to repair.
- Uncontextualized or unprovenanced items.
- Items that pose a threat to health and safety.

The guide goes on to caution that items selected because they could be sold in order to purchase better examples, or items that are selected for their potential

to generate income, should be widely consulted on before such a decision is taken, as financial gain or 'trading up' is not seen as best practice in British museums. The consequences of rashly or unethically disposing of an item could be: loss or damage of public trust in all museums; adverse publicity and long-term negative perceptions of the museum; loss of MA accredited status; disciplinary action from the MA. Disposal does not always mean selling or destroying an item; a museum may dispose of an item by gifting it to another museum or returning it to the donor. Providing disposal is handled in an ethical and transparent fashion it can be a successful method of keeping a sustainable museum collection.

MUSEUM TREASURES: GOLD MASK OF TUTANKHAMUN

On 4 November 1922 Howard Carter uncovered the intact tomb of Tutankhamun (d. 1323 BCE), sending ripples of excitement across the world as the treasures and mysteries of this ancient tomb were unearthed. Carter had been excavating in Egypt in search of Tutankhamen's tomb for over five years when he finally made his breakthrough, discovering twelve steps leading to a blocked-up doorway covered with seals. The steps were covered over with earth to hide the discovery as Carter cabled his sponsor Lord

Carnarvon in England to alert him to the spectacular find. The team had an agonizing wait of three weeks for Lord Carnarvon to travel to Egypt so that he might be present when the tomb was opened. Finally, on 26 November, the team began to clear the door and passageway, revealing evidence that tomb robbers had breached the grave but filled in their route. They came to another sealed door, in which Carter made a small hole and peered through. As his eyes adjusted to the light he realized the tomb was filled with objects. When asked by Lord Carnarvon what he saw, he could only reply 'wonderful things'.

It took many months to catalogue and remove the hundreds of items in the tomb, from beaded sandals to golden statues, but finally, two years after its discovery, the team of archaeologists were ready to open the tomb of the pharaoh, the first intact mummy of its kind to have been found, untouched for 3,300 years. One of the most iconic finds from the tomb was the golden mask of Tutankhamun which covered the face of the mummy. Made from gold, obsidian, lapis lazuli and glass, the mask is 54 cm high. It is reputedly an exact replica of the young king's face, so that his soul will recognize his mummified body and return for resurrection. The mask is part of the collection at the Egyptian Museum in Cairo. It remains one of the most instantly recognizable Ancient Egyptian artefacts.

THE RETURN OF DISPUTED ARTEFACTS

The circumstances of war, colonial occupation and sometimes unscrupulous collectors mean that the provenance of some museum artefacts is in dispute. Over the years a number of objects have been returned to their country of origin.* These include:

THE OBELISK OF AXUM Mussolini ordered his troops to remove the 1,700-year-old granite obelisk from Axum in Ethiopia and transport it back to Rome in 1937. The 24-metre-high obelisk had fallen over in the sixteenth century; once in Rome it was re-assembled with metal rods and placed near the Circus Maximus. The Ethiopian government secured an assurance in 1947 that all looted items would be returned. Yet it was not until 2005 that the obelisk was finally transported back to Axum, where it now stands alongside six other ancient obelisks.

EGYPTIAN FRESCOES In 2009 the Louvre returned five fragments of frescoes taken from a 3,200-year-old tomb near the Valley of the Kings. The French museum had purchased the frescoes in good faith in 2000 and 2003 but was subsequently informed by the Egyptian government that the artefacts had in fact been stolen from the tomb in the 1980s and should be

* Diplomatic discussions continue with a number of institutions over the return of disputed artefacts, such as the Elgin Marbles, the Benin Bronzes and the Rosetta Stone at the British Museum; and Nefertiti's bust at Berlin's Neues Museum.

returned. After the Egyptian government severed ties with the Louvre, the museum agreed to return them.

THE HOTTENTOT VENUS Sarah Baartman was an indigenous South African who was taken to London in 1810 and displayed all round Europe as the Hottentot Venus. Europeans were encouraged to marvel at Baartman's voluptuous figure – and the indignity did not end there. After her death at the age of just 26 her remains were kept at Paris's Musée de l'Homme for 'scientific study'. After a sustained campaign, France returned her remains in 2002 and she was finally buried in her homeland.

THE MUMMY OF RAMSES I A looted Egyptian mummy thought to be from the era of Ramses I ended up in Atlanta's Michael C. Carlos Museum after it was purchased from a small Niagara Falls museum. The team at the Atlanta Museum performed CT scans on the body. When it was confirmed the body was at least 3,000 years old they offered to return the remains to Egypt, suspecting it to be the body of Ramses I. The mummy now resides in Luxor Museum.

THE EUPHRONIOS KRATER In 1972 New York's Metropolitan Museum of Art acquired a 2,500-year-old terracotta bowl painted by one of the most celebrated artists of Ancient Greece, Euphronios. The Italian government, suspecting it had been looted, asked the Met for provenance. Records soon proved the bowl had been uncovered by grave robbers and sold on by art traffickers, and so in 2008 it was returned to Italy.

THE EUROPEAN
MUSEUM OF THE YEAR AWARD

The European Museum of the Year award is overseen by the Council of Europe. It is awarded to existing museums or galleries that have recently undergone refurbishment or expansion, or to brand-new museums. The award seeks to recognize museums from Council of Europe members (forty-seven countries) that have contributed to excellence in the museum sector. The prize has been awarded since 1977. Some of the notable winners have included:

Ironbridge Gorge Museum, UK (1977)

Peloponnesian Folklore Foundation,
Nafplio, Greece (1981)

Beamish Museum, UK (1987)

National Museum of Denmark, Copenhagen (1994)

Museum of the Romanian Peasant, Bucharest (1996)

National Conservation Centre, Liverpool (1998)

French Museum of Playing Cards,
Issy-les-Moulineaux (1999)

Victoria and Albert Museum, London (2003)

Kumu Art Museum, Tallinn, Estonia (2008)

Riverside Museum, Glasgow (2013)

Museum of Innocence, Istanbul, Turkey (2014)

Design Museum, London (2018)

WRONGLY LABELLED SPECIMENS

Research published in 2015 in the journal *Current Biology* suggests that over 50 per cent of all natural-history specimens in museum collections could be wrongly labelled. Researchers from the Department of Plant Sciences at Oxford University teamed up with botanists from the Royal Botanic Garden in Edinburgh to investigate the extent of incorrect labelling in museums. Looking at the 4,500 specimens of the African ginger genus *Aframomum* held in collections across the world, the scientists noted that at least 58 per cent of all samples of the plant had been wrongly named. Unfortunately these errors are often then fed into online databases, which further spreads the erroneous information, exacerbating the problem. Furthermore when plant samples are taken in the field they are often split and sent to various museums and herbaria across the world. The researchers examined this process by looking at samples of *Dipterocarpaceae*, a family of rainforest trees from Asia, of which 9,222 had been divided to make 21,075 separate specimens. By tracing where these samples were sent they discovered that 29 per cent had been given a different name to that of the original specimen.

With over 1.8 million named species on Earth, of which over 50 per cent have been discovered since 1969, it is unsurprising that mistakes in identification and labelling are made. Researchers suggest that

creating a worldwide online resource with the DNA of each species could help scientists and curators improve the accuracy of their labels.

THE BRITISH MUSEUM IN NUMBERS

Founded	1753
Number of overseas visitors	4 million
Number of visitors under 16	800,000
Number of visitors to the website	30.9 million
Number of storerooms	194
Number of objects in the collection	8 million
Number of volunteers working at the museum	600
Number of visitors* to the museum	6.2 million
Number of panes of glass on the roof of the Great Court	3,312
Percentage of the collection on show at any one time	1% (c. 80,000 objects)
Most searched-for term on the British Museum website	'Egypt' (53,000 searches/year)
Number of artefacts loaned outside the UK*	2,200 (to 113 venues)

* 2016/17.

ALFRED HITCHCOCK AND MUSEUMS

The famous film director Alfred Hitchcock (1899–1980) enjoyed using famous landmarks in his films, such as the Statue of Liberty in *Saboteur* (1942) and Mount Rushmore in *North by Northwest* (1959), but it was museums that he kept revisiting as a backdrop to some of his most famous films. Below are four Hitchcock films that featured a museum scene:

Blackmail (1929) Hitchcock's first sound film has its finale in a chase scene through the Egyptian rooms and over the domed roof of the reading room at the BRITISH MUSEUM.

Strangers on a Train (1951) We find menacing character Bruno appearing from behind columns at the NATIONAL GALLERY OF ART in Washington DC.

Vertigo (1958) Jimmy Stewart first sees Kim Novak sitting in front of the portrait of her supposed ancestor Carlotta Valdez inside San Francisco's LEGION OF HONOR museum.

Torn Curtain (1966) Berlin's ALTE NATIONALGALERIE's ornate tiled floor and labyrinthine interior provide the perfect location for Paul Newman's character to elude his pursuer.

THE GREAT DEBATE

On 30 June 1860 Oxford's newly opened Natural History Museum (then known as the University Museum) hosted Bishop of Oxford Samuel Wilberforce (1805–1873) and leading biologist Thomas Huxley (1825–1895) in a 'Great Debate' on Charles Darwin's theory of evolution by natural selection.

Darwin's *On the Origin of Species* had been published just over six months earlier and its ideas were hotly contested. As a result the British Association for the Advancement of Science decided to hold a debate pitching the Bible's creation story against Darwin's controversial theory. Wilberforce represented the Church but was not a stranger to academia, having gained a degree in mathematics, and was a member of the Royal Society. Huxley was a close associate of Darwin and a leading scientist; his eloquent defence of the theory of evolution gained him the nickname 'Darwin's Bulldog'. Over 500 people crowded into the Museum to hear the arguments, and yet the debate was barely covered in the popular press, meaning that most accounts of the event were written many years later. Both sides claimed victory.

One apocryphal anecdote from the event persists, which perhaps sums up the spirit of the debate. Wilberforce was said to have quipped to Huxley: was it 'through his grandfather or his grandmother that he claimed descent from a monkey?' Huxley was said to have replied: 'If then the question is put to me whether

I would rather have a miserable ape for a grandfather or a man highly endowed by nature and possessed of great means of influence and yet employs these faculties and that influence for the mere purpose of introducing ridicule into a grave scientific discussion, I unhesitatingly affirm my preference for the ape.'

MUSEUM TREASURES:
THE BIRTH OF VENUS

The Birth of Venus was painted by Sandro Botticelli (*c.* 1445–1510) between 1482 and 1485, after it was commissioned by the powerful Medici family. The painting depicts the moment Venus, the goddess of love, emerged fully formed from the sea, riding aboard a scallop shell and wafted to land by Zephyr, the personification of the west wind. *The Birth of Venus* was the first major work to be painted on canvas in Tuscany. Prior to this, wood panels were more usually used; however, as wood tended to warp in warmer climes, canvas – which had been seen as lower grade – became increasingly popular. For hundreds of years the painting hung at the Villa di Castello, the Medici country house outside Florence, before being transferred to the Uffizi Gallery, where it hangs to this day.

FBI'S MOST WANTED STOLEN ART

Back in 2005 America's FBI first released a list of its most wanted stolen works of art in the hope that the publicity would help to recover some of the priceless pieces. Since then a number of works have thankfully been recovered and the list has been updated. However, the majority of the works remain missing. Below is the FBI's list and progress on recovering the items:

1. IRAQI LOOTED ARTEFACTS In 2003 after the invasion of Iraq the National Museum in Baghdad was victim of a rash of looting. Between 7,000 and 10,000 historic objects and artefacts were stolen. In 2005 the FBI recovered eight cylinder seals (some 5,000 remain missing), and in 2006 one of the most important items, the statue of King Entemena of Lagash, was recovered by customs officers.

2. CARAVAGGIO'S *Nativity with San Lorenzo and San Francesco* In 1969 thieves broke into the Oratory of San Lorenzo in Palermo, Sicily, and took Caravaggio's *Nativity*. The painting, worth perhaps $20 million, has not been seen since.

3. DAVIDOFF-MORINI STRADIVARIUS Thieves broke into concert violinist Erica Morini's New York apartment in 1995 and made off with her $3 million Stradivarius violin. The violin, which was made in 1727 by master violin-maker Antonio Stradivari, remains at large.

4. TWO VAN GOGH PAINTINGS Robbers broke into Amsterdam's Vincent Van Gogh Museum in 2002 and stole *View of the Sea at Scheveningen* and *Congregation Leaving the Reformed Church in Nuenen*, valued at $30 million. The two paintings were recovered in Naples in 2016 (minus their original frames) and are now back on display at the Museum.

5. CÉZANNE'S *View of Auvers-sur-Oise* On 31 December 1999 as the fireworks went off to celebrate the dawning millennium, a thief broke into Oxford's Ashmolean Museum and took Cézanne's landscape *View of Auvers-sur-Oise.* The $4.8 million painting has yet to be recovered.

6. MAXFIELD PARRISH ARTWORK Two oil paintings by Maxfield Parrish were cut from their frames and stolen from a gallery in West Hollywood in 2002. The paintings were part of a series commissioned for sculptor and art patron Gertrude Vanderbilt Whitney's 5th Avenue mansion in New York. The whereabouts of the paintings, worth $4 million, is unknown.

7. *The Dance* by PICASSO, *Marine* by MONET, *Garden of Luxembourg* by MATISSE and *Two Balconies* by DALÍ were stolen by armed robbers from the Chácara do Céu Museum in Rio de Janeiro in 2006; the thieves used the bustling carnival crowds to distract from their heist and made a clean getaway. The paintings have yet to be found.

8. FRANS VAN MIERIS, *A Cavalier* This small portrait by Dutch master Van Mieris was stolen from the Art Gallery of New South Wales, Sydney, Australia, in 2007. It remains missing.

9. RENOIR's *Madeleine Leaning on Her Elbow with Flowers in Her Hair* In 2011 this masterpiece was stolen in an armed robbery on a private home in Houston, Texas. The painting has not been recovered.

10. In one of the most brazen art heists, in 1990 thieves dressed as police broke into Boston's ISABELLA STEWART GARDNER MUSEUM (*see p. 46*) and stole thirteen paintings by artists including REMBRANDT, VERMEER and DEGAS. The works, together worth over $500 million, are some of the world's most eagerly sought missing masterpieces.

LIGHTING MUSEUMS

Henry Cole (1808–1882), the first director of the South Kensington Museum (renamed the Victoria and Albert in 1899), famously regarded the study of objects and art in museums as an important part of public education for the working classes, remarking that a museum should be a 'schoolroom for everyone'. However, during the nineteenth century the working classes worked long hours with little time off, making a visit to a museum low on the list of priorities. Cole proposed evening opening as a solution, stating that

'the evening opening of public museums may furnish a powerful antidote to the gin palace'. But without natural daylight a tour of the galleries would be a gloomy affair. To rectify this, Sheepshanks Gallery, one of the newly built rooms at the South Kensington Museum, designed by Captain Francis Fowke, was to be furnished with gas lighting – making it the first artificially lit museum in the world. The Gallery opened on 22 June 1857 with 112 gas burners in the two large rooms and 84 in the two smaller galleries; this allowed the Museum to stay open until 10 p.m., immediately improving its visitor numbers. Fowke designed the room with the gaslights in mind, ensuring they mimicked or complemented natural daylight and minimized glare on the paintings.

The newfangled lighting was such a success that the Edinburgh Museum of Science and Art, Oxford University Museum (later the Oxford University Museum of Natural History) and the Birmingham Art Gallery all soon followed suit and installed gas lighting systems. The British Museum refused to permit gas lighting due to the risk of fire; however, in 1879 it became the first museum to install electric lights, with illuminations in the Front Hall, Reading Room and Forecourt. This early innovation was so successful it was rolled out across the Museum in 1890, a move that was warmly received by a journalist in the London Daily News (13 March 1890), writing: 'But doubtless among the crowds of ... visitors there must have been many to whom the electric light had its chief charm in the

Greek, Roman and Egyptian and Assyrian galleries. We may be wrong, but it seemed to us some at least of the classical sculptures looked more characteristic, more like themselves, so to speak, under the new light than even in daylight.'

MUSEUMS OF THE MUNDANE

Not every museum contains priceless artefacts. A number of museums around the world feature extensive collections of very ordinary objects. Below is a selection of museums of the mundane:

MUSEUM OF EVERYDAY LIFE, Glover, Vermont, USA This self-service museum* is housed in a shack in Vermont. It aims to celebrate not the exotic but the familiar objects that populate our lives.

BRITISH LAWNMOWER MUSEUM, Southport, UK A celebration of the humble lawnmower, with an extensive collection of vintage machines and a growing selection of 'lawnmowers of the rich and famous'.

MUSEUM OF BREAD CULTURE, Ulm, Germany A museum dedicated to bread, with 16,000 artefacts relating to bread but no actual bread. The founders believed that bread itself is not a museum exhibit

* The first visitors of the day are requested to turn the lights on, and the last to turn them off again.

but something that should be baked and eaten fresh each day.

Lᴜɴᴄʜ Bᴏx Mᴜsᴇᴜᴍ, Columbus, Georgia, USA
A collection of 3,500 metal lunch boxes, complete with decals of children's favourite characters.

Rᴀᴍᴇɴ Mᴜsᴇᴜᴍ, Yokohama, Japan This museum is concerned with the history and development of ramen noodles.

Sᴜʟᴀʙʜ Iɴᴛᴇʀɴᴀᴛɪᴏɴᴀʟ Mᴜsᴇᴜᴍ ᴏғ Tᴏɪʟᴇᴛs, New Delhi, India Celebrated at this museum is the fascinating history and evolution of the toilet from 2500 BCE to the present day.

Tʜᴇ Kᴀɴsᴀs Bᴀʀʙᴇᴅ Wɪʀᴇ Mᴜsᴇᴜᴍ, La Crosse, Kansas, USA 2,400 varieties of barbed wire are on display at this museum, which traces its impact on the division of land among settlers in the USA.

THE UFFIZI GALLERY

The building which today houses the Uffizi Gallery in Florence was commissioned by Cosimo I de' Medici in 1560, not as a museum but rather as a building to house the administrative and judicial bodies of Florence, hence its name *uffizi*, the Italian for 'offices'. Giorgio Vasari designed the U-shaped Uffizi Palace, including a secret corridor linking the building with the Pitti Palace. In 1580 Cosimo's son, Francesco I de' Medici, Grand Duke of Tuscany, set aside the top floor of the east wing to create a private gallery of some of the great family's many treasures. This private collection grew and grew with the continued influence, wealth and scope of the Medici family. When the last of the dynasty, Anna Maria Luisa de' Medici, died in 1743 she left the now enormous collection to the Tuscan state, specifying that the works should remain in Florence and that the Uffizi Gallery should become public. As a consequence the Gallery was opened to the public in 1769. To make the vast collection more accessible it was reorganized to reflect Enlightenment ideals, with the relocation of the scientific and natural-history specimens to La Specola – a Museum of Zoology and Natural History – and some of the statues moved to the Archaeological Museum and the National Museum of the Bargello.

Currently the Gallery is undergoing refurbishment as part of the Nuovi Uffizi (new Uffizi) project, which began in 2007 with the aim of increasing the

exhibition space. Instead of closing the whole Gallery for a number of years, the curators took the decision to close and refurbish just a couple of rooms at a time, allowing visitors to still enjoy the treasures during the process of modernization.

LARGEST ART MUSEUMS IN THE WORLD

Many museums and galleries hold innumerable items in their vast collections. However, only a small amount can be on show at any one time. To truly measure the biggest art museums one must consider the actual gallery space, indicating the area given over to physically showing the art. Below is a list* of the largest art museums in the world by usable gallery space:

* *Source*: worldatlas.com, May 2017.

MUSEUM	LOCATION	YEAR	SPACE (m²)
1. Louvre	Paris	1792	72,735
2. Hermitage	St Petersburg	1764	66,842
3. National Museum of China	Beijing	1959	65,000
4. Metropolitan Museum of Art	New York	1870	58,820
5. Vatican Museums	Vatican City	1506	43,000
6. Tokyo National Museum	Tokyo	1872	38,000
7. National Museum of Anthropology	Mexico City	1964	33,000
8. Victoria and Albert Museum	London	1852	30,658
9. National Museum of Korea	Seoul, South Korea	1945	27,090
10. Art Institute of Chicago	Chicago	1879	26,000

MUSEUM TREASURES:
THE TERRACOTTA ARMY

In 1974 some farmers were digging a well near the old Chinese capital of Xi'an in Shaanxi province in north-west China when they uncovered a fragmented clay figure, the first clue that this barren ground held an astounding secret. Archaeologists soon moved in and slowly unearthed an astonishing life-sized army of terracotta soldiers and horses surrounding the un-excavated tomb of Qin Shi Huang (259–210 BCE), the first emperor of China. Qin Shi Huang was a great and powerful ruler, who with his army of warriors had seized control of all China, and during his reign had built another great monument to his power, the

Great Wall.* Archaeologists ultimately uncovered some 8,000 terracotta warriors guarding the tomb of the ancient emperor, as well as terracotta acrobats and bronze swans, ducks and cranes. Historians marvel at the artistry of the warriors, each statue sporting differing hair, facial expression and accessories. The 4-acre Museum of the Terracotta Army opened at the site in 1979. It includes three major pits filled with row upon row of terracotta soldiers, allowing visitors to gain some sense of the scale of the enormous site. The Chinese government has also created two touring exhibitions to bring samples of the army to Europe and America.

WHAT'S EATING THE COLLECTION?

In recent years many of Britain's museums have been beset by pests. Clothes moths (*Tineola bisselliella*) have been eating valuable wall-hangings, carpets, costumes and artefacts in museums across the country. Some conservators blame climate change for the increase in clothes moths, while others point to the recent banning of the carcinogenic pesticide dichlorvos, which formerly kept the pest at bay. The historic buildings that are home to many of our most famous museums

* Very little of the section of the Great Wall of China built by Qin Shi Huang survives today. However, it was rebuilt by successive emperors. Most of the surviving wall was erected during the Ming dynasty (1368–1644).

are often full of nooks and crannies that are perfect for clothes moths to multiply in, and this means that curators and conservators must remain ever vigilant. To manage the infestations sticky pheromone-infused moth traps are used which mimic the scent given off by female moths, attracting the males, which become stuck to the traps, preventing them from mating. Any small object that has been attacked by moths can be placed in a freezer for a number of days, the low temperature ensuring that any remaining are killed off. The Museum of Fine Arts in Boston has an especially ingenious weapon against invading pests – a dog. Riley the Weimaraner has been trained to sniff out moths and beetles that could be hiding in any new acquisitions. This allows the conservators to treat pests as soon as they are discovered, preventing them from spreading around the precious collection.

PRIVATE MUSEUMS

Before the concept of a public museum, all museums were private, in that they were owned by an individual. Today a new spate of private museums – most frequently private art museums – have sprung up. These establishments (more than 200 of which have been created since the millennium) are often set up by wealthy individuals or corporations wishing to share their art collections with the world. The vast

majority of private art museums are concerned with contemporary or modern art, and with no shareholders or board members involved can be more cutting-edge or mono-focused. Below are some examples of private museums around the world:

JAMES TURRELL MUSEUM, Colomé, Columbia, was established in 2009 by Swiss art collector Donald Hess to showcase the coloured-light installations of contemporary American artist James Turrell.

ZEITZ MUSEUM OF CONTEMPORARY ART AFRICA, Cape Town, South Africa, the largest contemporary art museum in Africa, opened in 2017. It is based on the collection of Jochen Zeitz, former German CEO of Puma.

ELGIZ MUSEUM, Istanbul, Turkey, became Turkey's first public venue for contemporary art when it opened in 2001.

MUSEUM OF OLD AND NEW ART (MONA), Hobart, Tasmania, a varied collection of often controversial works of art from the collection of David Walsh, opened in 2011.

LONG MUSEUM, Shanghai, China, is one of a number of museums established by husband-and-wife art collectors Wang Wei and Liu Yiqian. The Museum has floors dedicated to Chinese antiquities, Chinese art from the Cultural Revolution and contemporary art.

NUMBER OF MUSEUMS IN EUROPE

The European Group on Museum Statistics (EGMUS) collects data from museums across Europe, providing a wide-ranging look at the continent's museum sector.[*]

COUNTRY	MUSEUMS	VISITORS/YEAR > 5,000
Austria	553	223
Czech Republic	484	247
France	330	185
Germany	6,712	2,129
Ireland	230	56
Italy	459	279
The Netherlands	694	480
Spain	1,504	847
Switzerland	1,108	315
UK	1,732	n/a

According to the Network of European Museum Organisations (NEMO), Europe as a whole has over 15,000 museums, which are visited by more than 500 million people each year.

[*] Data from a range of years 2010–16 depending on country.

DIGITIZING COLLECTIONS

Digitizing museum collections is the next step in the democratizing of knowledge and culture. Digitizing can be photographing an object, 3D scanning, digitizing a film or audio file – it is a way of making objects and the information about them available online. It is an enormous task, with each museum holding millions of objects. However, many institutions are using volunteers and crowdsourcing to speed along the process; for example, a volunteer might transcribe the inscription on an Anglo-Saxon cup, or tag and categorize a group of objects to make them easier to find during a digital search. By digitizing a collection, museums make it possible for researchers and the public to see artefacts from the comfort of their own home; it also allows museums to create online exhibitions and to reach a wider audience via social media. Although the technology to digitize collections has existed for a number of years, the complexity and time needed to plan and execute a digital strategy have meant that while some museums lead the way, others have been slow on the uptake, making online access to museum collections somewhat patchy. However, large institutions such as the British Library, the British Museum and the Smithsonian have been leading the way, and through partnerships with digital allies such as Google have been making great strides in opening up their collections to the digital age.

HOUSE MUSEUMS OF NOTE

The houses in which famous artists or persons of
renown have lived have frequently been preserved and
turned into museums dedicated to their celebrated
owner, lending visitors an insight into the lifestyle
and surroundings which inspired some of our greatest
writers, musicians and artists. Below are collected
some house museums of note (*see also Writers' House
Museums of Note, p. 53*):

WILLIAM MORRIS'S RED HOUSE, Bexleyheath, UK, epitomises the Arts and Crafts movement Morris helped to found. The house was designed by Philip Webb in 1859 and includes furnishings designed by William Morris himself, and paintings and stained glass by the Pre-Raphaelite Edward Burne-Jones.

MONET'S HOUSE AND GARDENS at Giverny, outside Paris. Thanks to the development of the portable tube of paint, Monet was one of the first artists able to paint out in the fresh air. It was at his home in Giverny that he created a wonderful garden, complete with Japanese-style bridge over the lily pond, which was to inspire many of his most famous paintings.

POLLOCK–KRASNER HOUSE, East Hampton, New York. The house and barn in East Hampton was bought by Jackson Pollock and his fellow-artist wife Lee Krasner in 1945 after securing a loan from art dealer Peggy Guggenheim. The floor of the barn-cum-studio retains the paint splatters left when Pollock created some of his most famous works.

KETTLE'S YARD, Cambridge, was between 1958 and 1973 the home of Jim and Helen Ede. Jim had worked as a curator at the Tate Gallery in London and collected a host of artworks, which the couple carefully and artfully placed among ceramics, glassworks and natural objects around their house.

LA CASA AZUL or FRIDA KAHLO MUSEUM, Mexico City, was the lifelong home of Frida Kahlo and later her husband Diego Rivera. In Kahlo's bedroom you can see her wheelchair and the bed with a mirror placed over it where she recovered from the bus accident that nearly cost her her life.

HANDEL HOUSE MUSEUM, 25 Brook Street, London. The famous composer lived in this smart townhouse from 1723 until his death in 1759. Handel spent much of his time composing and even rehearsing in the house, as his main performing space at the Covent Garden Theatre was shared with an acting company.

SIR JOHN SOANE'S MUSEUM, London. Renowned architect Sir John Soane bought and converted three houses in Lincoln's Inn Fields in order to better display his eclectic and impressive collection. In 1833 he secured an Act of Parliament to protect and preserve his house and collection for future generations.

It is commonly accepted among scientists (and the majority of the public at large) that the Earth was created over 4.5 billion years ago and that plant and animal life has slowly evolved since then following the rules of natural selection. However, in Petersburg, Kentucky, USA, an alternate theory is promoted via the Creation Museum. This Museum was established by Christian group Answers in Genesis in 2007 at a cost of $27 million to assert that the Earth is in fact a mere 6,000 years old, created by God himself in a matter of six days – taking a literal view of the book of Genesis. The Museum features displays arguing

that the fossil record was created after Noah's flood; that dinosaurs were aboard the ark; that the Grand Canyon was formed by the flood waters sent by God; and that metallic beetles' remarkable colouration exists not through natural selection but because God likes beauty.

THE BRITISH MUSEUM'S SECRETUM

The Secretum (originally known as the 'Cabinet of Obscene Objects') was created in 1865 – at the height of Victorian moral panic, reflected by the Obscene Publications Act (1857) – to house all the items in the British Museum deemed 'offensive'. In a rash of paternalistic concern about protecting the general public from obscene objects in the Museum's collection, a special room was designated in the stores where all erotic artefacts were safely deposited away from public view. Access to the Secretum was only granted to gentleman scholars who could demonstrate valid academic reasons for studying its secrets, further adding to its cachet. The Secretum persisted for a surprisingly long time, with objects added well into the 1950s. As the sexual revolution blossomed in the 1960s and curatorial practice demanded objects be kept in their cultural contexts, most of the objects were gradually returned to the main collection. Curious readers may satisfy their interest in the contents of

now disbanded Secretum by perusing below the list of objects included within:

- George Witt's collection of 434 phallic objects.
- A Roman sculpture of Pan fornicating with a she-goat.
- A stone fragment of a temple wall from India depicting lovers engaging in sex acts.
- A variety of eighteenth-century condoms made from animal intestines.
- Explicit Italian engravings illustrating Pietro Aretino's sixteenth-century pornographic verse.

The British Museum was not the only institution to lock away its erotic objects. In 1821 the *Gabinetto Segreto* (Secret Cabinet) was created to store the numerous obscene statues and frescoes found during the archaeological digs at Pompeii. The *Gabinetto* was considered better out of sight, out of mind and bricked up in 1849. However, it was later reopened and in 2005 was moved to Naples National Archaeological Museum.

INDEX

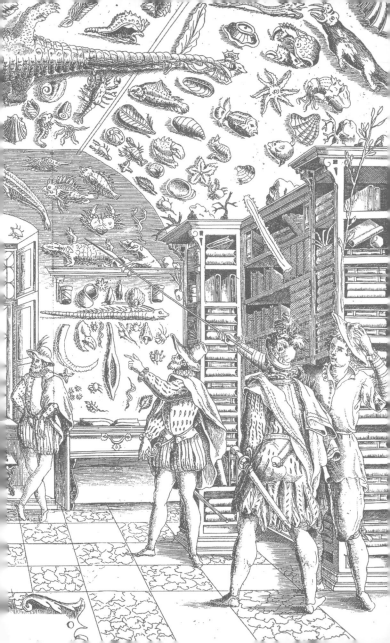

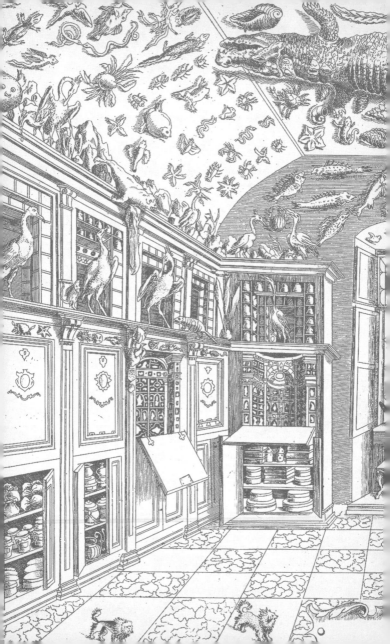